DOLCE VITA STYLE

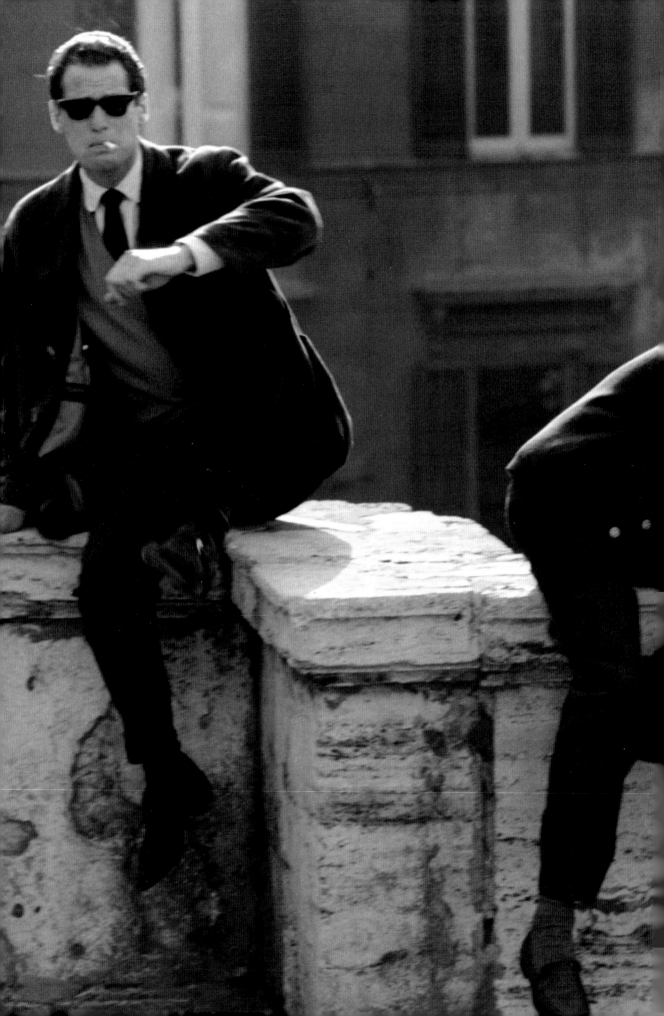

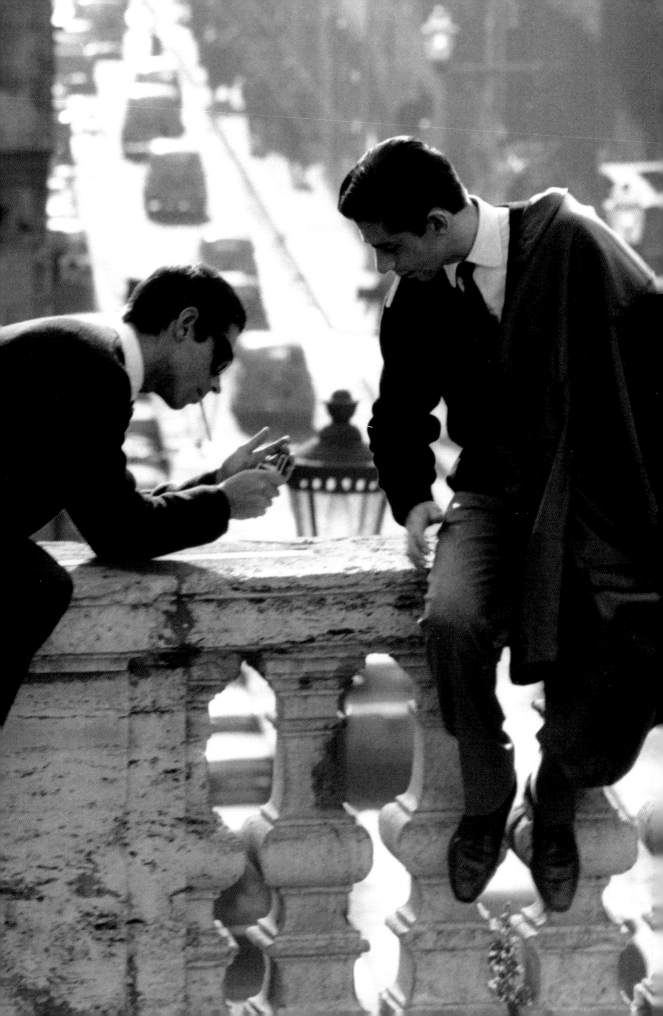

To Noëlle

"Good God, what a battle I had for La Dolce Vita *!"*
Georges Simenon,
chairman of the Cannes Film Festival jury in 1960

"On the avenues of Felliniland,
belle donne *wear gondola hats,*
clerics sport Gucci cassocks,
and nuns Gianni Versace shades."
Michel Grisolia

"La Dolce Vita *made a fortune.*
I got virtually nothing.
Rizzoli offered me a gold watch."
Federico Fellini

Previous pages: Roman men in the 1960s, or the disoccupati: *white shirts and black shades.*

Translated from the French by Simon Pleasance, Fronza Woods and Molly Stevens.

© 2005 Assouline Publishing
601 West 26th Street, 18th floor
New York, NY 10001, USA
Tel.: 212 989-6810 Fax: 212 647-0005
www.assouline.com

ISBN: 2 84323 731 9

Color separation: Gravor (Switzerland)
Printed by Grafiche A. Pizzi (Italy).

JEAN-PIERRE DUFREIGNE

DOLCE VITA STYLE

ASSOULINE

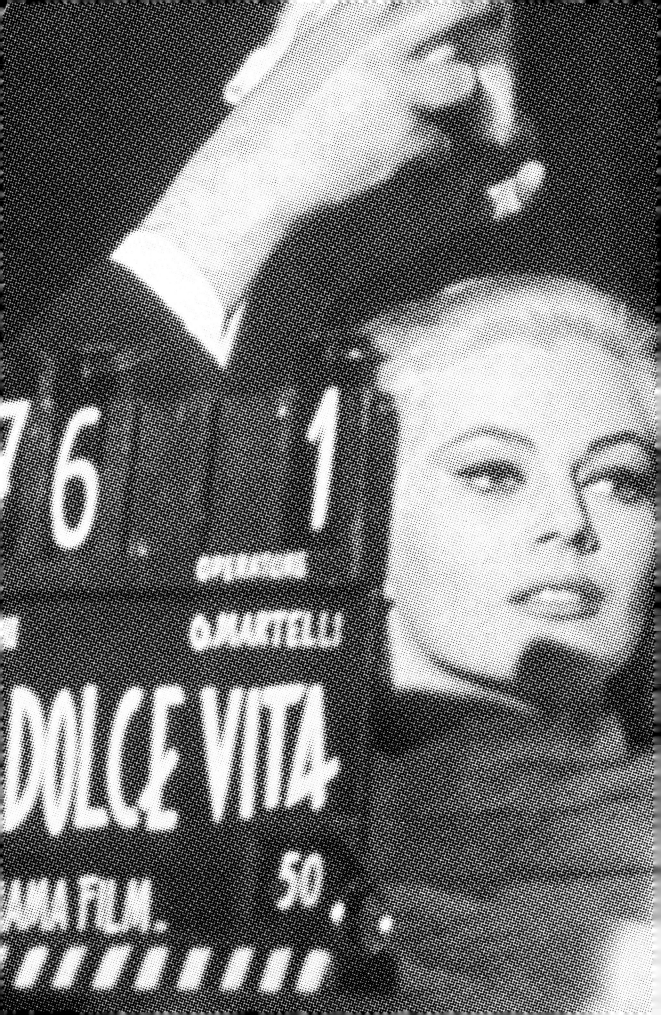

[CONTENTS]

[MEMORIES OF
THE END OF THE WORLD]

The night is quiet over Rome. Balmy. Restaurant terraces are packed. At one table, an American is surrounded by friends, real, and momentary. A rather shrill voice asks: "Why do you live in Rome?" The American turns his head, smiles, and replies: "Rome is the only place to be to wait for the end."

This exchange is just a snippet from *Fellini's Roma* (1972). The American is a writer, Gore Vidal, who has seen his famous novels and plays either adapted by himself for the big screen—like *The Best Man*—or affably butchered like his unforgettable *Myra Breckinridge*, which became a most dubious film. He does not give a damn, and from his lofty position reflects on both disasters and misrepresentations with irony. Rome is the city of irony, reigned over by the Pope and parties given in the palaces and villas of the aristocracy, be it titled or moneyed. Gore Vidal is famous, and thus deserves his place in this "eternal" city, which is, first and foremost, universal. He passes for an *enfant terrible* of American letters. A successful dandy whose books sell millions. So his place is as justified in Rome as it is in *Fellini's Roma*, in which Rome is the star, twelve years after that other film where Rome was the superstar—*La Dolce Vita*. He has seen it, of course. Everybody has seen *La Dolce Vita*. Gore Vidal had brilliantly adapted Tennessee Williams' *Suddenly Last Summer* for Joseph L. Mankiewicz, who then managed to ruin his health, his future, and his producer in Rome, at the Cinecittà Studios, with *Cleopatra*. Another *Dolce Vita*, just as sumptuous, and just

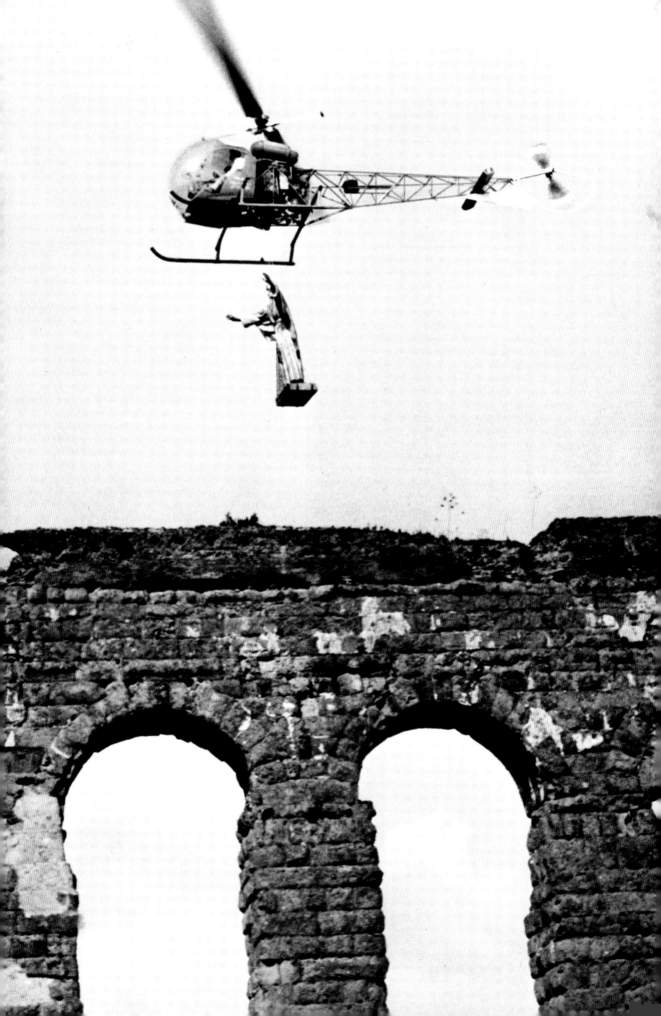

as tragic. From another time. The time when, with one film, with such a sweet sounding title, arose the end of an era.

But what is *La Dolce Vita*?

Let us keep things simple, and offer a neutral rundown. If that aesthetic bombshell can be resumed, that is.

The film squeezes all the protagonists into a single space—Rome the Catholic, the ancient—and a single week.

Seven days, or rather seven evenings, followed by seven nights ending in seven dawns. And as we know from Rimbaud, "dawns are upsetting." With each and every sequence the adventure starts out during the evening, finds its moment of greatest bustle in the dead of night, and ends up in the vague atmosphere of early morning. Each dawn introduces a temporary and glum conclusion, where the spells of the night fall apart. For the first time, Fellini does not follow a linear scenario. Rather, he pins together fragments and scattered moments, whose sole link is the wandering and debasement—accepted and probably sought—of a man, Marcello Rubini (Marcello Mastroianni), one of the rare lead characters to have a profession: he is a journalist. Or rather a gossip columnist, a *soiriste*—literally a "night person"—as they used to be called. What is he after? High society scandal: idle gossip.

The film opens with a gigantic shadow over Rome and the ancient aqueduct. The shadow, which might appear menacing, is actually that of a huge statue of Christ, bound for a church and hanging from a helicopter, in which Marcello is sitting.

Then he goes to a restaurant where a prince is having dinner, and meets Maddalena (Anouk Aimée), a high society millionairess. He invites her for a drive in his car, and they end up renting a prostitute's room (Adriana Moneta). At dawn, he goes home, where his mistress Emma (Yvonne Furneaux) has tried to commit suicide. He takes her to the hospital.

He has to go to the airport where journalists are awaiting the arrival of a star, Sylvia Rank (Anita Ekberg). After the press conference, Marcello offers to show her Rome, and takes her to St. Peter's, where she runs up

the 700 steps wearing a cassock. Then he takes Sylvia to a nightclub after a tiff with her husband (Lex Barker). At the club, she starts dancing in a most sensual way, while her husband gets drunk. She drives off with Marcello, and they stop in the countryside to imitate the wolf. Then they drive back to Rome. A kitten appears in front of them; Sylvia sends Marcello to get some milk for the kitten. When he returns, she's splashing about in the Trevi Fountain. He manages to get her back to her hotel. Nothing happens between them. Can a journalist believe in an affair with a star? Their relations are never anything but practical: he gets photos and a "piece," she gets people to talk about her—"even nice things," to quote Ava Gardner, at the time a star of stars along with Elizabeth Taylor.

Accompanied by Emma, he goes to a village in the Roman countryside where two children are claiming they have seen the Virgin Mary. There is much commotion here, with spots, cameras, mikes and photographers. A priest rails at the hoax, but others are keen to believe it is true. Torrential rain and a storm chase everyone away, and Marcello knows that the children are imposters.

Still with Emma, Marcello goes to a party at the home of his friend Steiner (Alain Cuny), a writer who is his role model, a bit the way an elder brother who has realized his dreams might be. This is an intellectual gathering, with an architect, an American poetess, and a painter. The painter asks Marcello how he is getting on with "his novel," which he will never write. Steiner introduces his wife and children to them, talks kindly with Emma—who is seduced by this peaceful family happiness—and lets them hear the sounds of nature he has recorded. He also talks about his fear of being hemmed in, as he currently feels, when Marcello sees an example of human success in him.

In a seaside inn, Marcello is served by a little girl, Paola (Valeria Ciangottini), whom he calls an angel. He returns to Rome to learn that his father (Annibale Ninchi) has come into town to see him. He meets him on the Via Veneto and takes him to a cabaret, where he introduces him to

Fanny (Magali Noël); his father goes off with Fanny. But in the hotel where he takes her he passes out.

Marcello is invited to a party in the luxurious villa of a princely family where he bumps into Maddalena, who asks him to marry her, but when he rejoins her, she is with another man. The party ends in a torchlight procession to morning mass in the chapel.

In his car, at night, Marcello has an argument with Emma. He leaves her by the roadside. And comes back to look for her in the small hours. When he learns that Steiner has committed suicide after killing his children, he is told to go and find Mrs. Steiner (Renée Longarini) who is unaware that her husband is dead and that photographers are in front her home, waiting for her to appear.

Marcello then goes to a producer's bungalow near the Fregene Beach for an orgy in celebration of Nadia's (Nadia Gray) divorce (then banned in Italy), during which she does a striptease. At dawn, all those taking part go to the beach, where fisherman have pulled a monstrous fish up onto the strand.

Kneeling in the sand, Marcello sees far off the blonde girl from the little inn on the beach; she waves at him, shouting words he does not understand. He goes off with his fellow orgy revelers.

This attempt at a deliberately neutral synopsis shows the disjointed appearance of the film's plot. And yet, each shot and every sequence, each evening and every dawn have an amazing aesthetic density. And an amazing modernity—a modernity of the cultural and sociological variety. Were it not for the cars and phones, the film might well have been shot in the twenty-first century.

Why? Because *La Dolce Vita* is a self-contained world. A world in a desperate state. Where human beings do not change but plunge inexorably into a kind of non-existence, ruled solely by restlessness, but a restlessness that is motionless.

Opposite page: *La Dolce Vita*'s last scene:
Marcello at daybreak after the last party.

With each and every
sequence the adventure starts
out during the evening,
finds its moment of greatest
bustle in the dead of night,
and ends up in the vague
atmosphere of early morning.
Each dawn introduces
a temporary and glum
conclusion, where the spells
of the night fall apart.

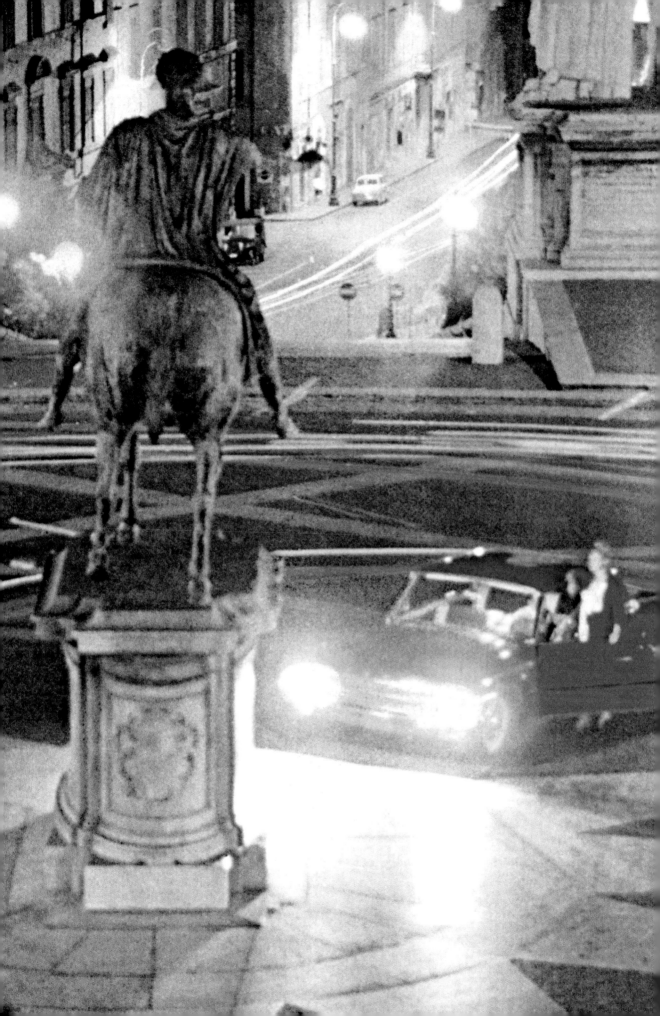

The night is quiet over Rome.
Balmy. Restaurant terraces
are packed. At one table,
an American is surrounded by
friends, real, and momentary.
A rather shrill voice
asks: *"Why do you live in Rome?"*
The American turns his head,
smiles, and replies: *"Rome is the
only place to be to wait for the end."*

It is a world governed by imagery, a quasi-virtual world ahead of the invention of the Internet, a world in which television is really beginning to get a foothold, and in which illustrated magazines—forerunners of future cult-of-the-personality magazines—are also triumphant.

In these seven nights (circles) of *Inferno*, an ancient hell—not the Christian variant, without eternal flames—a gray and dusty hell where there is no need for torment because what reigns here is probably worse: disenchantment, no future, and real despair, Fellini-Dante is not guided by that absolute poet, Virgil, but by a hack journalist, Marcello.

"For me, *La Dolce Vita* is just an account of the day- and night-time travels of a two-bit journalist," observed Fellini.

But what does a journalist do, no matter how disenchanted and spineless he may be? He invariably reports a truth.

Through Marcello and his photographer, Paparazzo (Walter Santesso), Fellini ushers in "the age of the image." We know the extent of its influence. More or less admitted "voyeurism" has become a television recipe for success, while English tabloids have replaced the never named scandal sheet for which Marcello and Paparazzo work. To this day, each shot in *La Dolce Vita* remains a fragment of eternity, although it is still a raw account of a bygone period.

For nothing has changed, just as nothing changes in this film, which has attracted more commentary than any other in the past half-century. Here again, let us pass the mike to Il Maestro (as Fellini was called, with deferential smiles at Cinecittà's Teatro Cinque), Il Poeta as he was ironically referred to by film critics.

"The characters are motionless because their society—which is ours—has come to a halt, and waits. They are motionless, even in their frantic din. They are people who live out extinct myths. The quest for truth has become a matter for reporters and for the glass eye of a camera. And this eye is so dilated that it no longer has any human scope. Truth slips away

Opposite page: Fellini, fashion launcher, photographed by William Klein.
Following pages: Left: Sketch for a Valentino coat for the 1990-1991
Fall/Winter collection, by Mats Gustafson. Right: Sunset over the Coliseum.

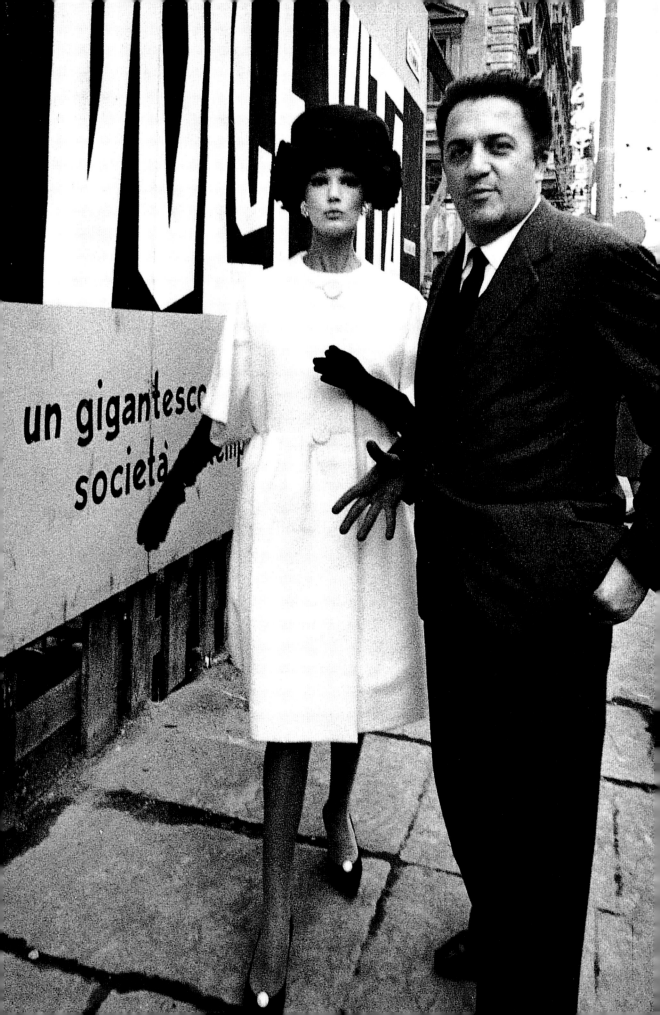

and carries on its racket. The monster eats its own tail. Silence is no longer; people writhe to music, and the whole film is dominated by this acoustic obsession. People are afraid of silence, because they are so afraid of having to listen to their own remorse. Seven days and seven nights of motionlessness. The narrative doesn't exist: all that can exist is the time spent waiting."

For *La Dolce Vita* (which was unsuccessfully translated for its release in France as "la douceur de vivre" or "the sweetness of life," an expression running totally counter to the substance of Fellini's film, and probably expressing an unintentionally ironical cynicism) has become a cliché. These days, the slightest party is given the Dolce Vita label; it is photographed and written about by a gossip columnist, or even, more harshly, by a crazed nightclubber working for a trendy paper, one or two stars of the moment remunerated by a nice fee and icons, gay and otherwise, making the news.

In this film, which at times flirts with the fantastic through the outstanding sets and costumes created by Fellini's favorite art director since *Nights of Cabiria*, Piero Gherardi, there is a grandiose dreamlike quality that will reach its apotheosis with *Fellini's 8 1/2*, and above all, with *Juliet of the Spirits*. But it is an apparent oneirism, duly tempered by the reality of the world described. A mental and poetic realism—a somewhat psychoanalytic realism, Il Maestro having discovered Freudianism through his own shrink Dr. Ernst Bernhard, (recommended by his friend, the cinematographer Pasquale De Santis). This too is a form of total modernism; in the late 1950s, people did not go around "Lacanizing" to death, out of sheer snobbery, but before long everyone would be on the couch, out of need, and because of fashion.

Fellini almost invented this world that took place in Rome and its outskirts, observing its society like a voyeur. He "took" his models from

Opposite page: Real-life High society acting out "the sweet life."
Princess Galitzine photographed by William Klein for *Vogue*.

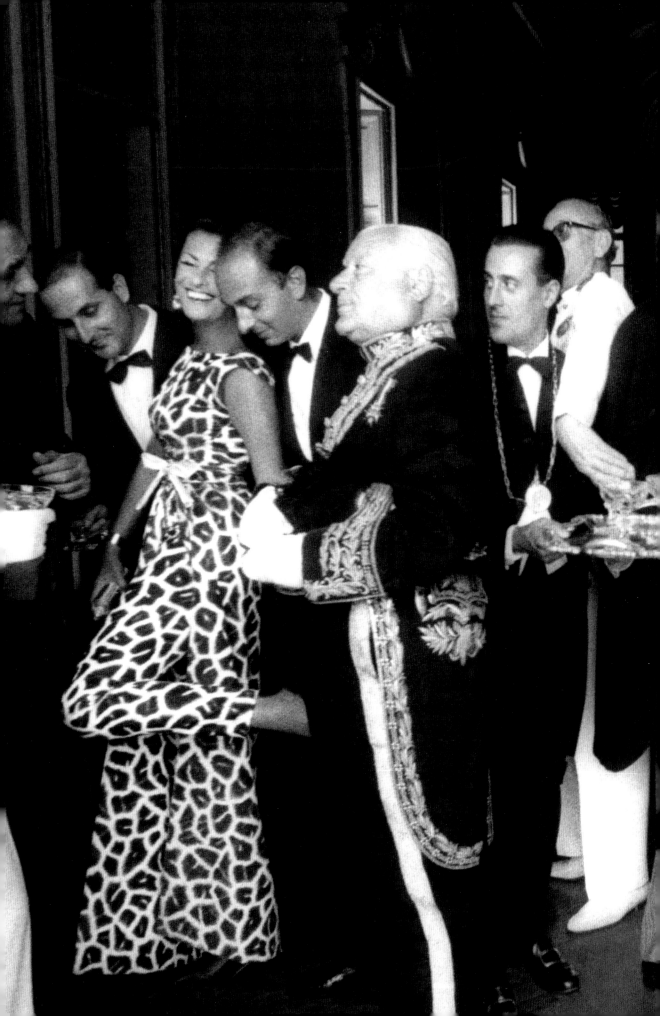

the circles he moved in, and drew inspiration from fascinating faces, creating the characters that have become legendary today. The omnipresent "paparazzo" (Tazio Secchiaroli), who in fact found fame because of the film, and the Roman women from the "Dolce Vita" years point to where the director found his inspiration and what fascinated him. The list is impressive. From Domitilla Ruspoli to Princess Laudamia Hercolani, from the princesses Irene Galitzine and Luciana Pignatelli to Lucia Rizzoli, Marella Agnelli, Marchioness Christina Pucci, from Countess Volpi (played by Monica Vitti) to Countess di Robilant—they all personify an aristocracy in which beauty, elegance and style come together.

Because the black-and-white used by the director of photography Otello Martelli is at once metallic, cold and yet rendered succulent in all its various shades, and because not one inch of set and not one lapel escaped the eagle eye of Piero Gherardi, Rome is turned into a masterpiece of artifice that springs from a magnified reality and aesthetic ideal.

"I am a lie that tells the truth," Jean Cocteau proclaimed. And Fellini stated in the title of a book of interviews: "I am a big liar. A big "menteur-en-scène," a clever wordplay on the French for director, "metteur-en-scène."

For the world lies, as much as cinema does, says Fellini. And, in a few years, after neo-realism, films changed as a result of this remarkable feat of Fellini's seven nights and seven dawns.

The journalist gave up his trilby, his raincoat (Bogart-style) and his fight for truth for the dinner jacket, gossip, the photo scoop, and the staging of news. Men's fashion followed: in fashion shows, very handsome, very sulky young men strutted their already weary nonchalance, wanting to show only their look and mark the end of "fighters," workaholics, and wonder boys. To the point of the summery elegance of the unemployed man—in his crumpled white suit, dark shirt and scarf loosely tied at the neck—in the final orgy.

Previous pages: Left: The 1960s take off: Fellini, Mastroianni and Jean Shrimpton photographed by David Bailey. Right: *Dolce Vita* fashion photographed by Gian Paolo Barbieri. Opposite page: Princess Hercolani by William Klein for *Vogue.*

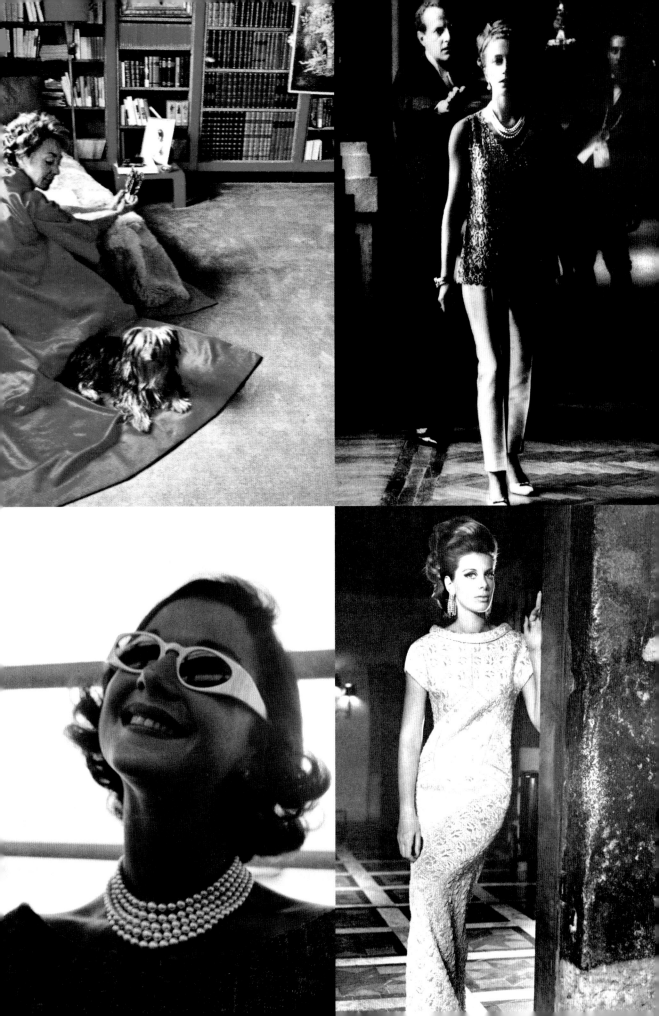

It was during this time (during those nights), that black sunglasses became a staple, even after dark. Elegance (everyone is elegant in the film) broke out of golden living rooms and burst onto a new scene (abandoned lots, the street, 3 bedrooms). And let's not forget the famous swim in the Trevi Fountain.

It's all in there. Beyond its beauty, the scene is important because it invented a new freedom. It introduced a new vision of the world, a new way of being modern, one that since, has never stopped being imitated, reinvented and plagiarized. It is similar to the rupture caused by Marcel Duchamp's *Urinal,* a piece that cleared new ground in Modern Art for several generations of artists to come (many of whom simply have followed suit). The beloved movie star in a long dress (designer, surely) takes off her pumps and slides into the water of the Trevi Fountain.

It became the model of freedom of expression, an act that took elegance out of exclusive, "god fearing" High society. In liberating style from tacit and ultra-conventional rules, Fellini created a fresh way of being that would inspire not only the avant-garde of cinema, but also advertising and fashion. By blending genres, he wrote a new sociological vocabulary that present day image "makers" (especially in fashion) continue to tap. He also opened the way for the eruption of the 1960s, when living a "Dolce Vita" took on a London spin, with insolent youth rebelling again the "old world."

The movie star also took on a new status. What was once inaccessible became familiar. You would see her in the street, in a restaurant, in a nightclub. With time, she would hire bodyguards, a way of fighting off an invasion of privacy that she herself propelled by commingling with the throngs of her fans.

In deference to Hollywood, the star was of course blonde. In this case she was Anita Ekberg. The other women—the "real" ones—were brunettes (Anouk Aimée, Yvonne Furneaux). And each of their paths

Previous pages: Marisa Berenson in 1965, an icon of elegance photographed by Henry Clarke for *Vogue.* Right (from left to right, and top to bottom): Lucia Rizzoli, Marchioness Pucci, Countess Crespi, and Princess Pignatelli.

leads to solitude. Maddalena gets lost escaping; there are no rules, no boundaries, she is led by her search for pleasure and her dread of boredom. Emma, who cannot stand this new freedom because of her sense of morality commits suicide (like Alain Cuny, Steiner the "wise man," who gives up on confining apparent happiness). Let us not forget that *La Dolce Vita* is set solely in Rome and its environs, and that suicide is a sort of ancient death. So the sea-monster in the final scene on the Lido Beach was often interpreted as the suicide of the whale otherwise known as Western civilization.

The casting is a work of genius. Anita Ekberg is the perfect choice. She had the talent. She was 56" around the bust, but who knew that her IQ was also big? Did Howard Hughes, who gave her her debut, and Frank Tashlin, who starred her in his first films with Jerry Lewis and Dean Martin, know she was more than a buxom splendor? She was a wonderful "Sylvia" who played her role with perfect feline instinct and female intelligence. Blond, curvaceous, her mouth, her eyes and voice, her taboo: she had everything necessary to become the idol, the sacred image that would transcend time.

A beautiful, adored star caught in a paparazzi trap is a cinematographic source that that cannot ever be exhausted. From Brigitte Bardot in *A Very Private Affair* to Nicole Kidman in the ads for Chanel N°5, cinema has always kept this myth alive. The scene has also played a constant role in fashion. Whether launching a collection or introducing a line, designers, stylists, photographers and models have dug into *La Dolce Vita* for more than fifty years. Arthur Elgorth put Claudia Schiffer in the Trevi Fountain for Valentino; Steven Meisel recreated stripteases and press conferences with Monica Bellucci and Isabella Rossellini for Dolce & Gabbana, who themselves are immersed in the *Dolce Vita* atmosphere. Periodically, magazines revisit the legendary film to conjure up the elegance and the decadence. Only sometimes do they

Following pages: Left: The young Valentino in his workshop in the early 1960s.
Right: Claudia Schiffer wearing one of his creations
in the Trevi fountain, photographed by Arthur Elgort in 1995.

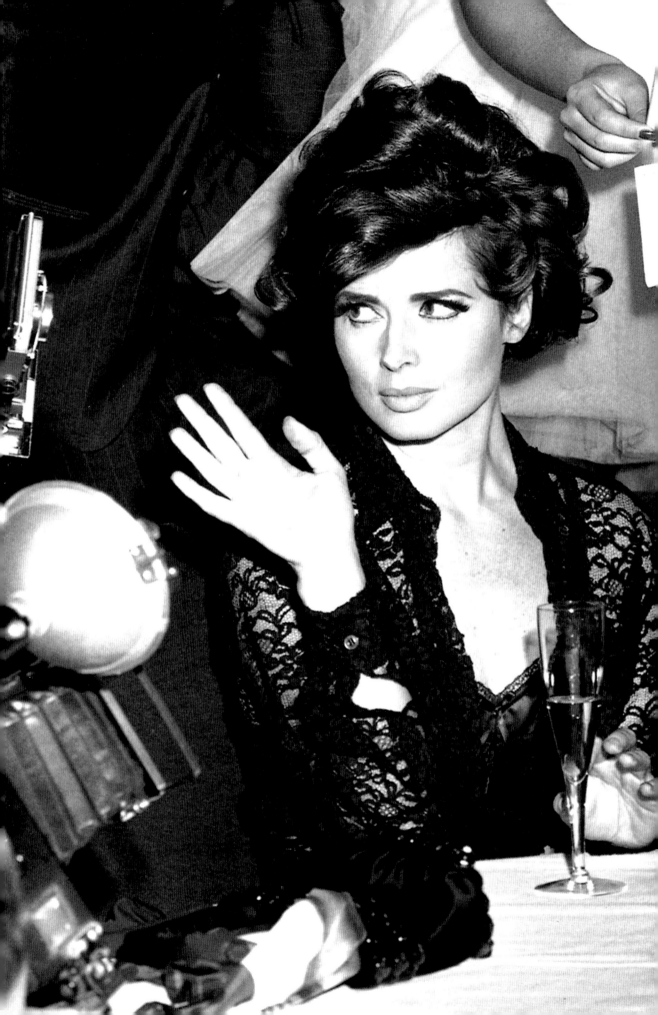

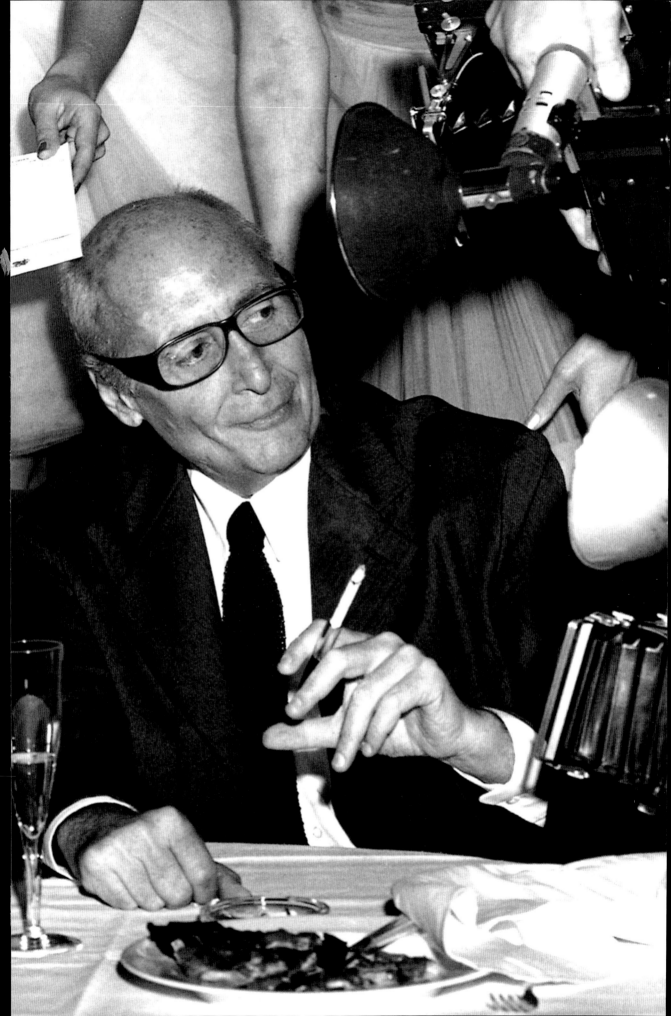

succeed. But, they never forget the black sunglasses.

La Dolce Vita cascades with glamour. Magnificent clothes, lots of make-up, wonderful props, including those ubiquitous dark glasses, which marked their entrance into a modernity that will not let go of them to this day, where they showed up in *Men in Black* and on such French talk shows as *Dark Glasses for Sleepless Nights,* a perfect scaled-down version of three hours of *Dolce Vita.*

So the young Valentino, a neighbor, without knowing him yet, of Federico Fellini (who had already won two Oscars for *La Strada* and *Nights of Cabiria,* one after the other in 1956 and 1957) also watched this great imperial circus of disenchantment ("having fun is more boring than working," observed Baudelaire) and glamour—a term coined by Hollywood, and very hard to translate into other languages, let alone feel.

Valentino Garavani had 26 years of seeing all and recording everything. This effervescence, which took its time

Previous pages: Dolce & Gabanna = *Dolce Vita.* Isabella Rossellini presents the "Dolce Vita" collection in an ad campaign by Steven Meisel. Opposite page: Eva Herzigova at the Cannes festival wearing the "Adèle" necklace designed by Cartier in 1995. *Paris-Match,* May 23, 1996.

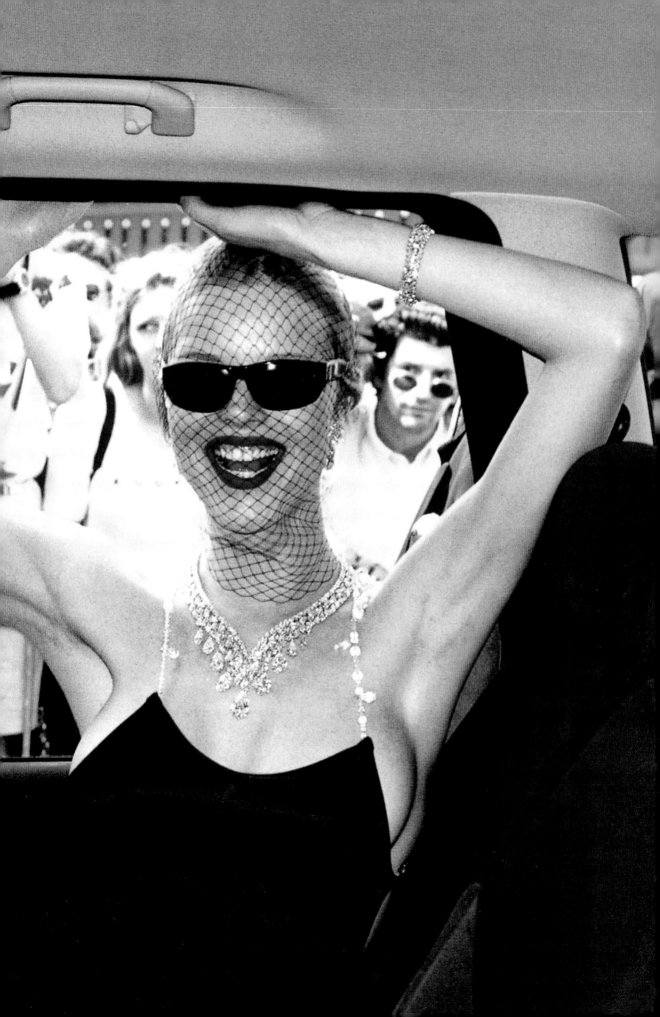

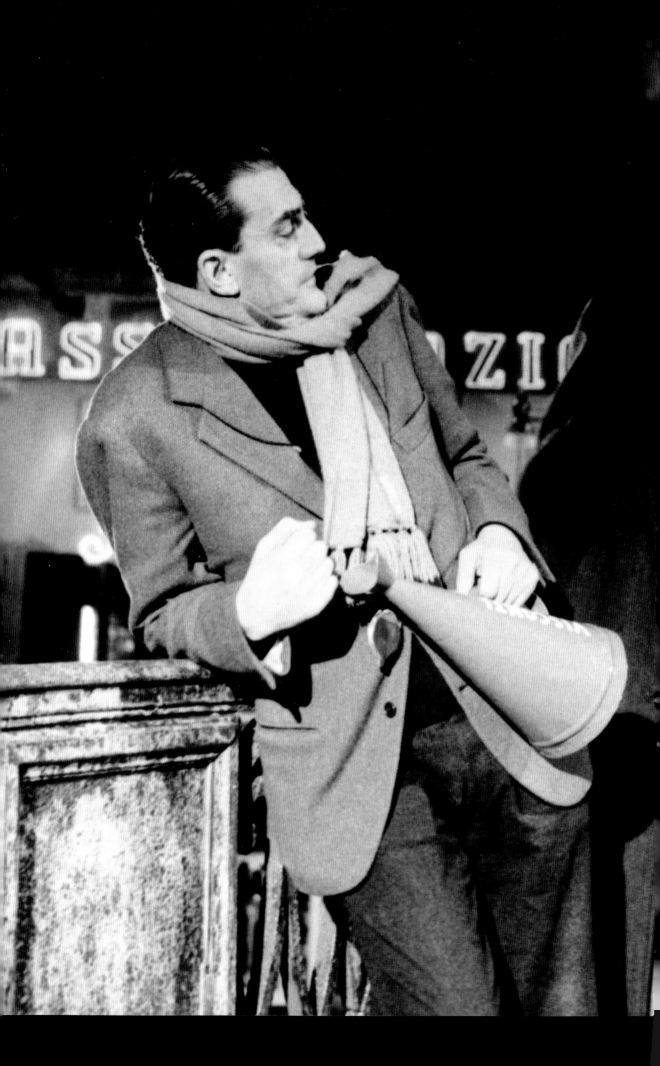

but played on overexcitement, would feature in his early work. In the following two years, Liz Taylor, while filming *Cleopatra* at Cinecittà (four hours late) would cast her lovely eyes on the young Valentino's fashion show. She chose a white chiffon dress, which she would wear for the première of *Spartacus*. Valentino was launched, and would go on dressing stars. The cinema and the countless photos in the celebrity magazines and the glossier international fashion magazines turned the young Garavani into the great Valentino.

Valentino's vintage dresses are all the rage today. Those earlier ones; the ones that followed *La Dolce Vita*, the ones that have gone down in the history of glamour, the ones that date from times long gone—times that were clothed by him with nothing short of genius. All the rage for whom? Top models and superstars like Julia Roberts. These vintage dresses from another era are in the headlines of today's magazines. They are worth their weight in gold, so to speak, because they date from an alleged golden age.

A weird golden age.

Opposite page: *White Nights*:
Mastroianni directed by Visconti.

"It's the vogue for 'things were better before,'" says Karl Lagerfeld. "What are we talking about? Hollywood in Technicolor? Personally, I know that in the 1950s the food was unhealthy, women were whitish, streets were disgusting, and people were not very well groomed. Women's make-up was too heavy, their hair was greasy, and their legs not very slender." In a few words, the master of Chanel draws a precise portrait of any actress starring in the days of the Italian neorealist movement. The only thing he leaves out is the hair under the arms.

It is an age with which *La Dolce Vita* broke once and for all.

And the *Dolce Vita* did not only impact women. They say Roman men also took great care of their appearances (and still do, but in a different way) during the blessed—should we say "damned"—period in which Fellini reigned on Via Veneto. This Roman masculine elegance triggered a chic, relaxed style that was freed from the constraints of classical sophistication, and that would greatly influence fashion in the United States. Dressing the greats of Roman film, the master tailors from Brioni opened a boutique on Via Barberini and it became a regular stop for the Hollywood stars shooting at the Cinecittà studios. From Henry Fonda to Kirk Douglas, from Victor Mature to Rock Hudson, handsome Americans adopted the Roman style—which quickly became real competition for Savile Row—and brought it back to New York and Hollywood. They went to Battistoni for shirts, Franceschini for shoes, and to Caraccini, Cifonelli, Guliano or Datti for custom-tailored suits, if it were not Brioni. To seal the Rome-New York connection, let's remember that Fellini's Trevi Fountain scene was inspired by a photograph of Francis Scott and Zelda Fitzgerald from the 1920s—the jazz era—taken by Pierluigi Praturlon. During their honeymoon, the stylish wife of the author of *Tender is the Night*—imagine a jazzy Gwyneth Paltrow—dove into New York's Union Square fountain in a short flapper dress. So as not to be outdone, her husband jumped into the Plaza Hotel fountain in a tux.

Opposite page: The Americans in Rome: Victor Mature dressed by Brioni.

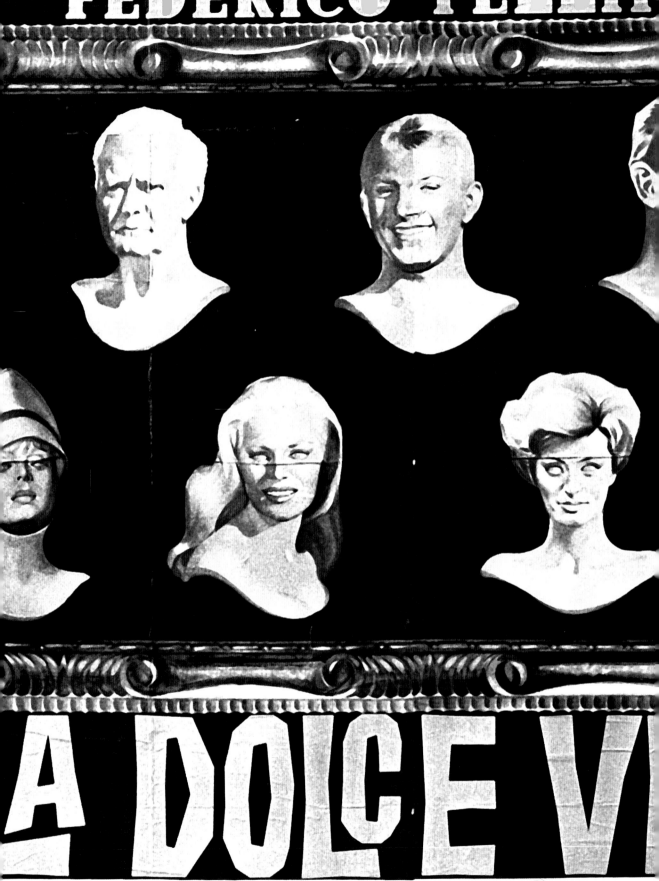

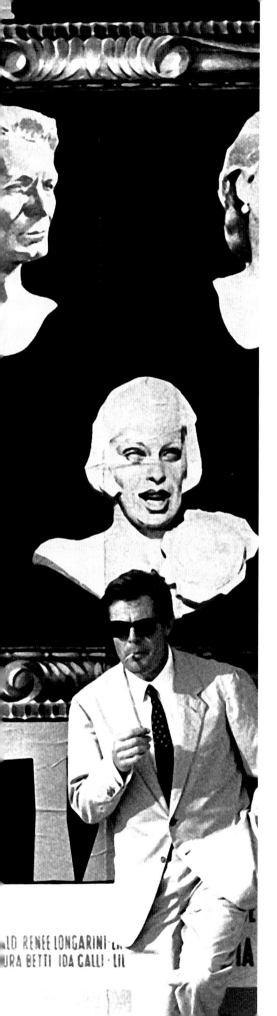

The universality and the globalization of *La Dolce Vita* is no fantasy, it is no dreamed phenomenon as described by a film-maker in Rome in the late 1950s, but a real fashion and counter-fashion, a life style and a kind of restless indolence in a period of unlikely or thoroughly new jobs; an international state of mind, another globalization in fact, which affects all the developed countries.

La Dolce Vita was a mirror, and fifty years later we still come upon our own reflection in it. And we recognize ourselves in it. Are we living in another "Dolce Vita" while terrorism, AIDS, and world crisis all run rife? Probably because the bitter taste of happiness, albeit adulterated, and the protection of our individuality come at this price: surviving the end of our world.

Opposite page: Mastroianni in front of the *Dolce Vita* poster at Cannes in 1960, the year it won the Palme d'Or.

[VIA VENETO: PARADISE ROAD]

1959. The young Valentino Garavani is 26 and has not yet dropped his surname and written his first name on shop fronts in Rome, Milan, Paris, and New York. He is not yet living in the Palazzo Mignanelli, on Rome's Piazza di Spagna. He is just starting out. Starting out in a city where parties are followed by more parties, not only in palaces, but also in such unlikely places as the Baths of Caracalla, empty lots, the beach huts at Ostia, and the pinewoods of Fregene. These parties are like magnets attracting the whole world.

They often start with a chance encounter on the Via Veneto, which runs gently down from the Pincio (one of the seven hills) in a sweeping arc, at times very steep. It runs through the Ludovisi neighborhood, climbs up to Bernini's Triton Fountain in Piazza Barberini—with its ancient walls—to

Opposite page: A night like any other on the Via Veneto, in 1959.

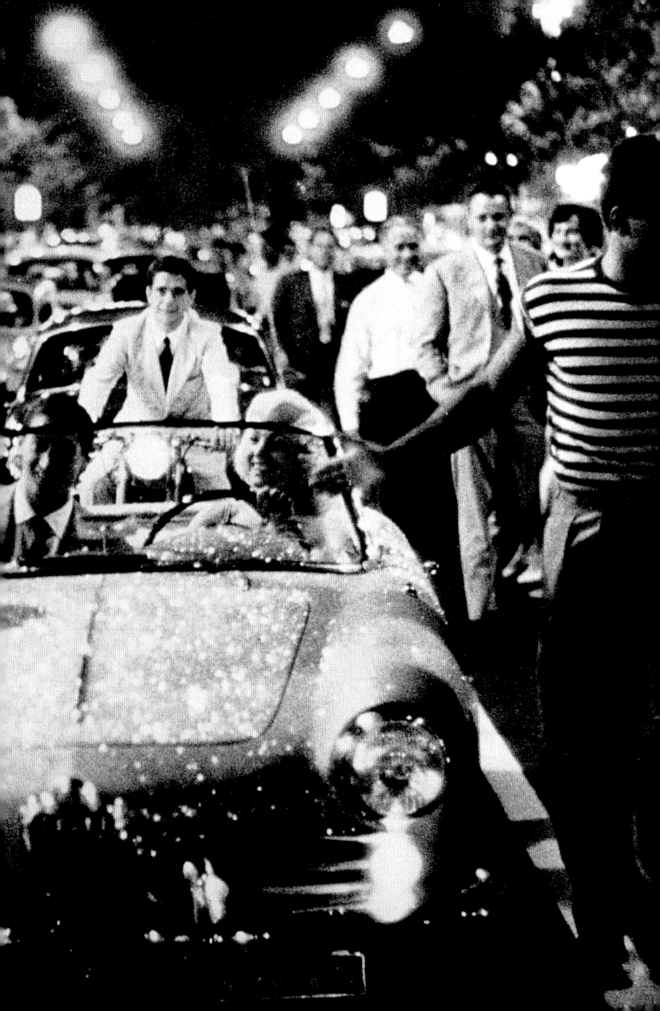

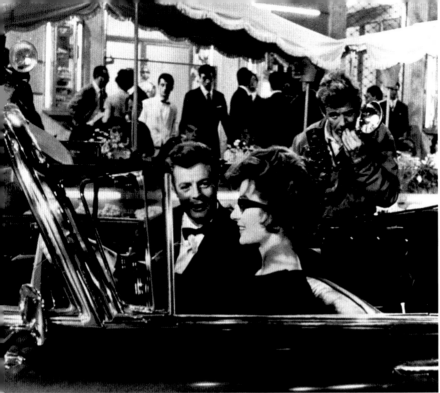

the Muro Torto and the Porta Pinciana. Two rows of plane trees provide it with a ceremonial hedge. It is invaded by cafés and hotels, the Caffè Rosati, the Strega, the Doney, and the Café de Paris. Not so long ago, in 1954, the Excelsior and the Grand Hotel played host to Humphrey Bogart and Ava Gardner, the stars of *The Barefoot Contessa*. A drama involving impossible love, film and powerlessness. King Farouk, cutting a noteworthy figure of an exile in a strange world, strolls the Via Veneto. The café and restaurant terraces spill over onto the pavement, and the roadway is cluttered with limousines and convertibles, as well as little Fiat 500s and scooters.

Well before Federico Fellini turned the Via Veneto into a legend, it had already been the meeting place for a Rome that was chic, intellectual and rowdy, where dandies and journalists rubbed shoulders with politicians, artists, and society people of all calibers. The boom of Cinecittà added the glamorous film crowd to this cosmopolitan parade. America came to make films here. Everybody then contributing to fashioning the spirit and taste of the day ended up on the Via Veneto. Mingling with this strange throng were photojournalists working for major illustrated newspapers like *Oggi* and

Above: From film to life, Via Veneto: (left) Mastroianni and Anouk Aimée, (middle) a band of *Dolce Vita* merrymakers, (right) Anita driving her car at two in the morning.

[46]

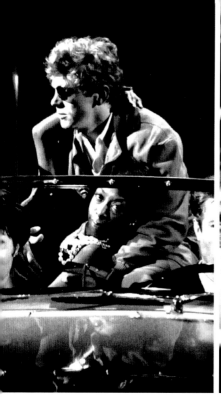
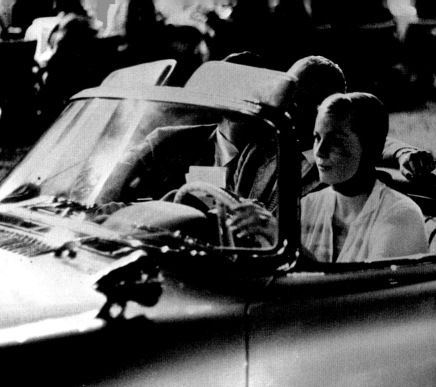

scandal sheets of differing degrees, and they rounded off this unlikely fresco, which was as cinematographic as you wanted it to be.

Fellini, whose offices were a ten-minute walk from there, on Via Alessandria, and his routine at the Café de Paris, ended up in the eye of this whirlwind. Here, his film found its natural set and its matrix; it would reveal to the whole world a cosmopolitan lifestyle in which elites rub shoulders with misfits in a frantic dash aimed at emerging new pleasures.

The 1950s were coming to an end. The success of *La Dolce Vita* would attract lines of buses filled with tourists, an invasion which would soon and forever destroy that extraordinary period. Fellini commented thus, half ironically, and half bitterly: "As a rule, Italians hated my film, but the comments from foreigners living in Rome were favorable. Tennessee Williams, for example, was enthusiastic. The cinema is a strange profession. Someone makes a bitter film, putting the best of himself into it, and what happens? He increases tourism!"

In the 1960s, the hub of high society activity shifted to the Piazza Navona, built on the site of the old Diocletian Circus, whose elliptical shape it has

Following pages: Late afternoon or at dawn… The party is over.

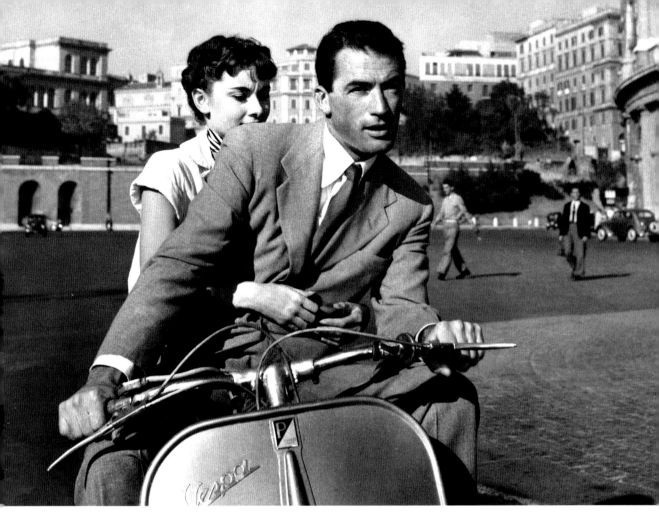

retained, and which is another scenographic gem in the heart of Baroque Rome, at once more spectacular and more intimate.

But for the time being, imported by Hollywood, an aura of intense sensuality then surrounded the image of Italy in the Anglo-Saxon imagination—embodied by the curves of the Via Veneto.

The release of *La Dolce Vita* would ripple well beyond the reasonable limits of debauchery of the Eternal City, and the Via Veneto became the center of a new world intoxicated by an effervescent modernity that was open to every manner of freedom. Or rather to every manner of license.

So for some fifteen years the Via Veneto would, with much panache, keep its place as a large stage open to one and all in the heart of the city; stuck between the ancient forum and the traditional need to *fare figura*, that is to say, "make a good impression" with a look that "is quite something," during

Above: (left) *Roman Holiday*: Audrey Hepburn on a Vespa with Gregory Peck, (right) Roman lazing about: Vittorio Gassman, the quintessential Roman according to Fellini.

the *passeggiata* or evening promenade. Romans like pretence, that perfect, but too obvious elegance. Romans are universal, because many of them are foreigners. Well-to-do families speak French, and everyone in the Via Veneto set understands English.

It is a theater, the theater of the twentieth century where the crowd is a spectacle—for itself, first and foremost, of course. Everyone goes to the Via Veneto to see other people, and everyone is one of those other people, too. Ordinarily, the curious bystander does not enter into such subtleties. But fashionable places—and this is what the Via Veneto was, in spades; filled with people busily keeping an eye on every little thing they did and every gesture they made, as well as every detail of their appearance—have the power of making anyone venturing into them very conscious of himself or herself. *La Dolce Vita* is the fractured tale of this mishandled consciousness.

Following pages: The Via Veneto recreated at Cinecittà.

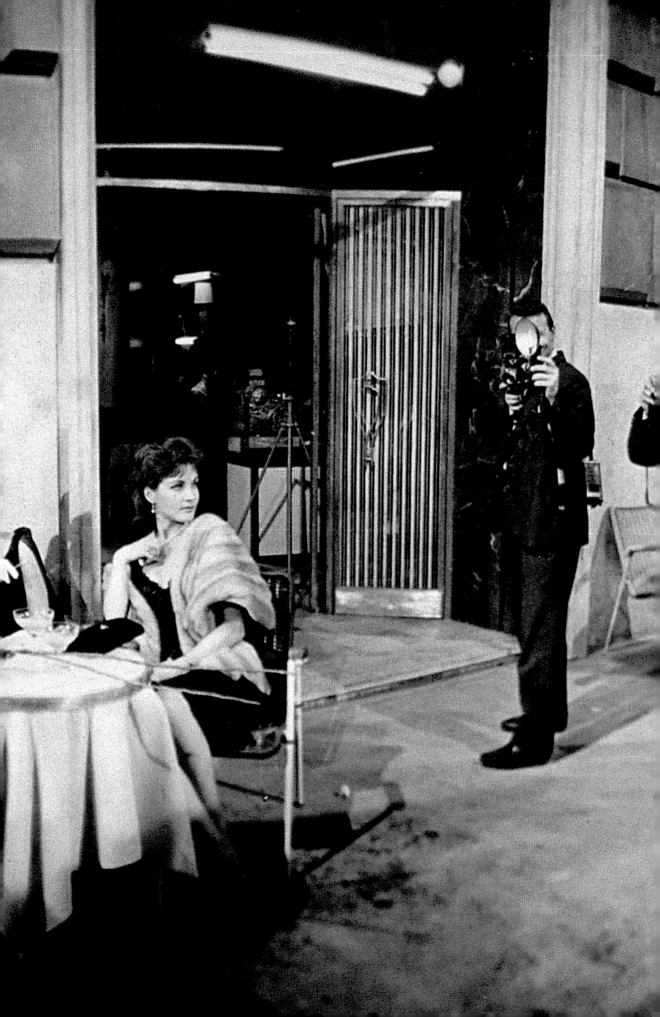

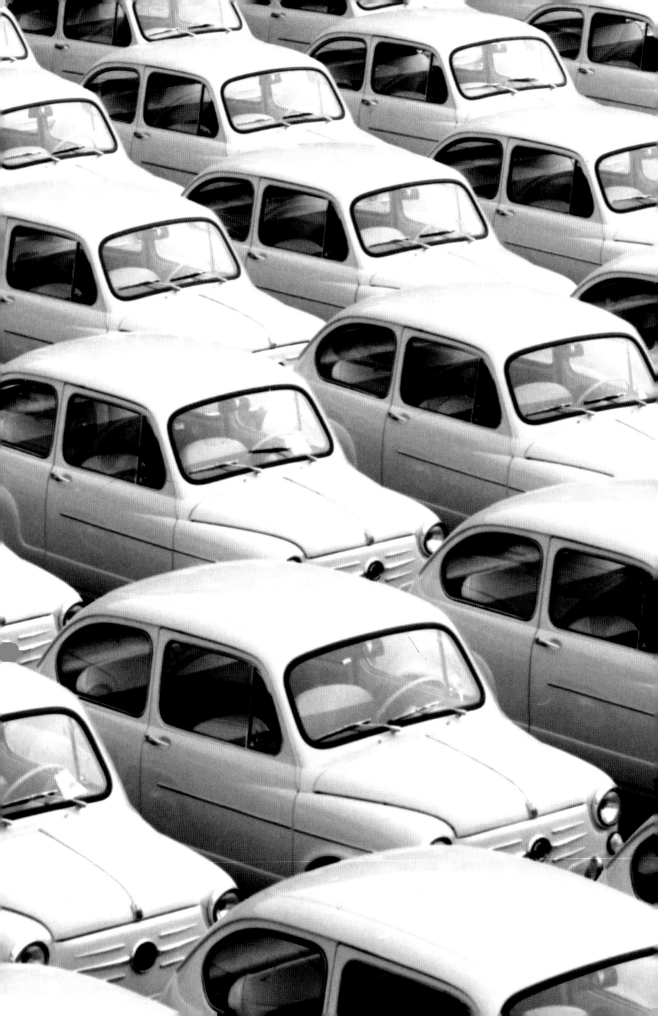

So isn't the world but a stage? The crowd plays the part of the stars. Especially when stars come and swell the crowd. This was a godsend of a place for the gutter press, working for no less than a dozen agencies: from ambushes to car chases, and from kicking up a fuss to coming to punches, relations with the stars then had something vaudevillian about them. These were the beginnings of the great media circus drawn to the rich and famous, or those claiming to be. Like probing chroniclers, Fellini and his co-scriptwriters, Ennio Flaiano and Tullio Pinelli, describe the birth of this phenomenon in *La Dolce Vita*, live, in close on three hours, with an irony tinged with anxiety.

The meeting of two sensualities, in an incredibly 1950s version of some Henry James novel—where the sensual is always ready to explode the respectable—that of young America embodied by stars like Ava Gardner, and that of decadent Europe, represented by a procession of grand society figures and aristocrats living life to the full—is always fascinating.

Opposite page: The Fiat revolution. Here, the Seicento.

Well before Federico Fellini
turned the Via Veneto
into a legend,
it had already been
the meeting place
for a Rome that was chic,
intellectual and rowdy,
where dandies
and journalists rubbed
shoulders with politicians,
artists, and society people
of all calibers.

L'EUROPEO

SETTIMANALE POLITICO D'ATTUALITÀ

Federico Fellini

presenta

LA STORIA

[PAPARAZZO, KING OF THE RATS]

Still 1959. During the filming of *La Dolce Vita*, one particular word—no, more than a word, a proper name—cropped up: Paparazzo. The name of the photographer (Walter Santesso) who goes everywhere with the journalist Marcello Rubini (Marcello Mastroianni). The proper name (without a first name, which prevents there being any real identity, not to say humanity) would become a common noun, like the actual title of the film. Its plural form, paparazzi, would become a term of public ridicule, with an element of pillorying—an extreme example being the stolen shot of Jackie Kennedy Onassis naked on the island of Skorpios as JACKIE O became the sign of a Roman nightclub, in the seventies. This phenomenon would carry on up until the car crash in the tunnel under the Pont de l'Alma in Paris, in which Lady Di and her lover perished.

Even when the film was first released, the absence of any first name prompted some viewers to think that Paparazzo was a nickname, a journalese slang term to describe this little thief, not to say rapist, of images, this fair-haired murderer of private life. Fellini often explained this name, which he said, came from papatacci (mosquito) and razzo (flash). But also, and more (or less) unwittingly, from the name of a former classmate in Rimini. Paparazzo travels about either by scooter or in a Fiat 500 (1956). Such vehicles can go anywhere. Like today's Smart cars, or the Austin "minis" from the 1970s. The legendary Cinquecento became another symbol of post-war Italy. This was Italy's economic boom; a time when everyday objects were given style and design. It was the golden age

Opposite page: Stolen image: Secchiaroli does not yet have his press card, so he asks another photographer to make some pictures for him. Following pages: Left: Paparazzo: Walter Santesso. Right: The model: Tazio Secchiarolli.

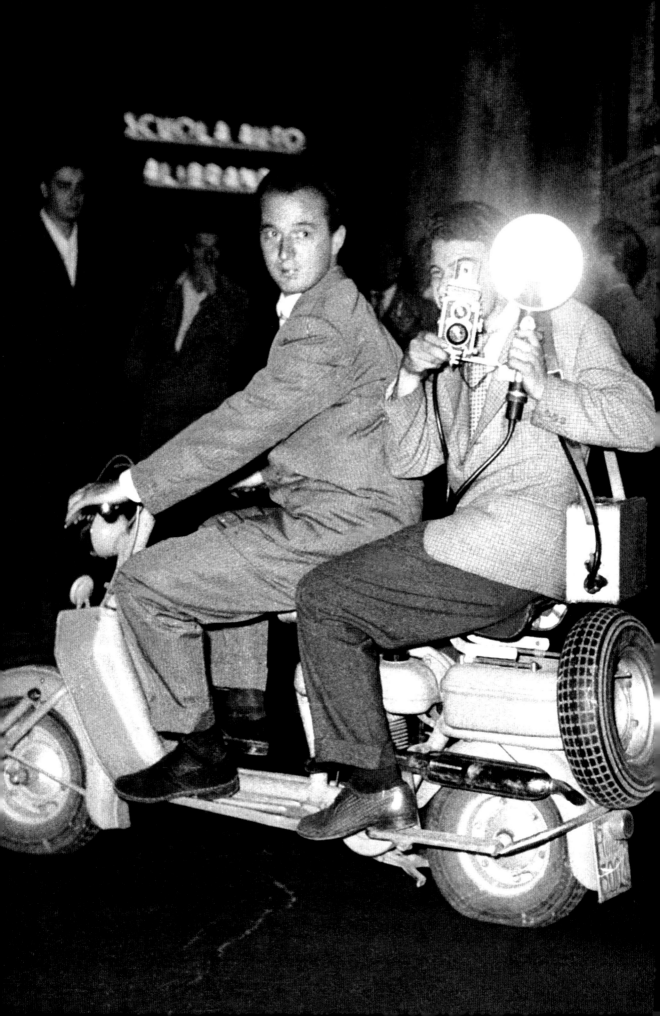

of "Made in Italy" cars, and it reached its peak with the merging of Ferrari and Pininfarina. While the young and beautiful cruised about in their Testarossas or in their Superamericas—which came out of this renowned merger—millions of more modest drivers chose to ring in the 1960s in Fiat's fantastic Cinquecento (exhibited at MoMA in New York). It was in Rome that this new Italy was best represented. And the scooter became the symbol of the country's exuberance as much as—perhaps even more than—the Fiat 500. The unforgettable *Roman Holiday* of Audrey Hepburn and Gregory Peck on a scooter is another key image from those years. Then essential for any paparazzo, it has now been mostly replaced by motorbikes. We can only wonder about the effect of replacing charm with efficiency.

Paparazzo existed. In the 1950s. And Fellini and his scriptwriter Ennio Flaiano met him. On Via Veneto, obviously.

Ennio Flaiano described himself as a "caffè writer." He would settle down at a table and watch. His observations led to a sarcastic wit with which Fellini was well acquainted since Flaiano had written the screenplay for *Variety Lights*, which Fellini co-directed with Alberto Lattuada in 1950. He also worked for Roberto Rossellini, Mario Monicelli, and the comic actor Totò. Then he worked just for Fellini. Federico liked his rational cynicism, which inspired him, for he himself was more poetic and affably grumpy.

On an August evening in 1958, while watching the antics of photographers going after a scoop from their lookout post at the Café de Paris, Fellini and Flaiano noticed Tazio Secchiaroli, the real model for Mastroianni's sidekick, Paparazzo, astride his Lambretta.

Secchiaroli took photo after photo of Anita Ekberg and her fleeting spouse, Anthony Steele, in the middle of a domestic dispute. He was hit by the actor-director Walter Chiari, whom he had caught with Ava Gardner. He also photographed the beautiful Ava with David Niven. He tailed King Farouk. Secchiaroli was not afraid of coming to blows if it meant getting a scoop.

Fellini and Flaiano invited him to their table. They had a character. He told them a few trade secrets: some actresses eager to be stars, for example, agreed to be photographed. Even posing as couples, and not necessarily lawfully wedded. Others, on the contrary, tried to be discreet. When a famous and preferably illicit couple was spotted, two photographers would watch them like a hawk. One of them would let down the tires of the couple's car; there would be a tiff, and then photos would be snapped at point-blank range. The photo could bring in anything from one to six million Italian Liras—$500 to $3,000.

It was all just a set-up, because in some cases there was no point in letting down the tires; the quarrel was phoney and rigged solely to get the couple on the front page of the celebrity magazines.

Tazio Secchiaroli, the king of the paparazzi who died in 1998, was honored in 2003 with an exhibition at the Niépce Museum in Chalon-sur-Saône, birthplace of the inventor of photography. The show included a portrait of him on his Lambretta. And his best productions.

Nowadays this method still applies. People—celebrities—"sell" the exclusive rights to their wedding, or the birth or adoption of a child, as they do for their meetings, needless to add. There is still the hunt, of course, which is the paparazzo's real job—and in the jargon the paparazzi are called "rats." In 1962, when Louis Malle filmed the aptly titled *A Very Private Affair* with Brigitte Bardot and…Marcello Mastroianni, he brought in paparazzi to hound Bardot. Things ended badly. There was a suicide. This is just what Flaiano and Fellini had sensed from their Café de Paris observation post. A presentiment. Which they understood, accepted, and developed.

There is a terrible moment in *La Dolce Vita* when the paparazzi take snap after snap of Mrs. Steiner's face, just when she has learnt that her husband has committed suicide, after killing their two children.

It is a most painful moment like the one when, toward the end of the film, Laura Betti plays the part of a star—though she is just a singer in the

Following pages: Left: Anita's arrival in *La Dolce Vita*.
Right: Luchino Visconti and Florinda Bolkan.

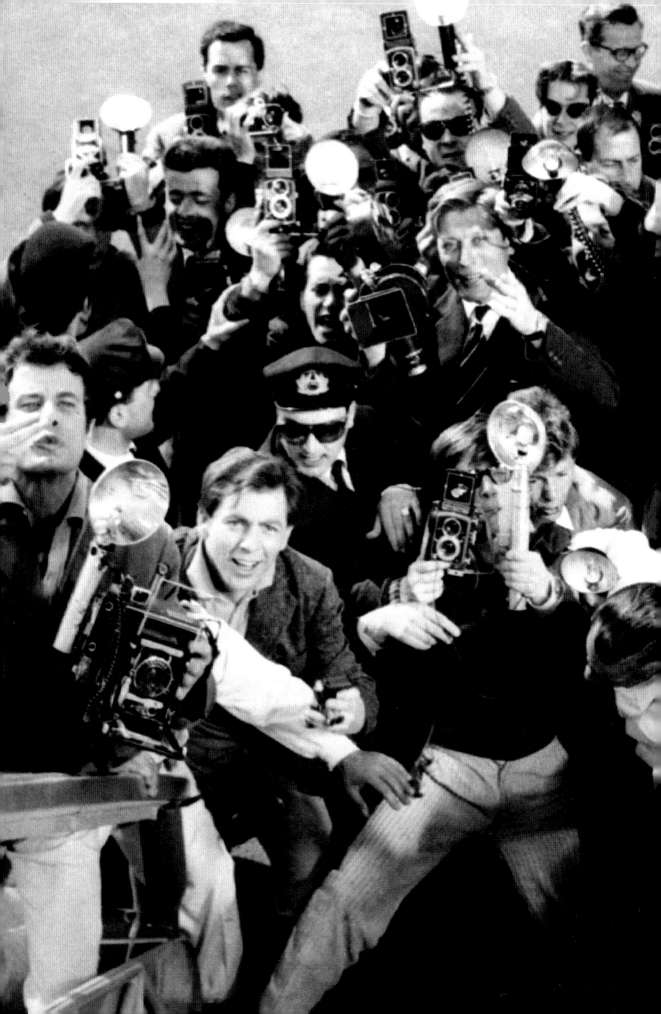

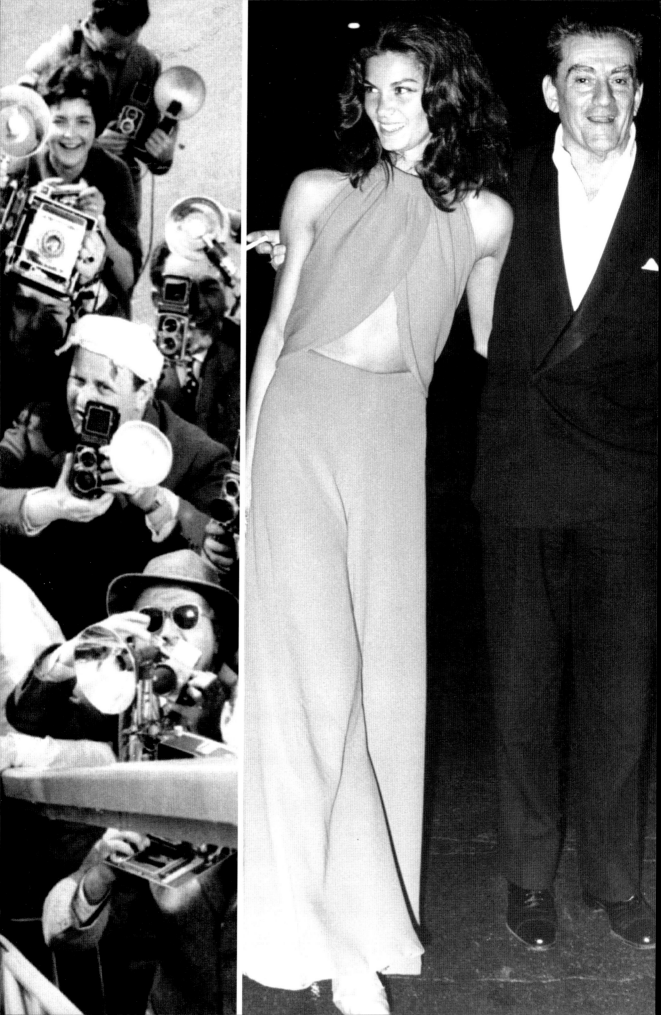

When a famous and
preferably illicit couple
was spotted,
two photographers would
watch them like a hawk.
One of them would
let down the tires
of the couple's car;
there would be a tiff,
and then photos would be
snapped at point-blank range.
The photo could bring in
anything from one to
six million Italian Liras.

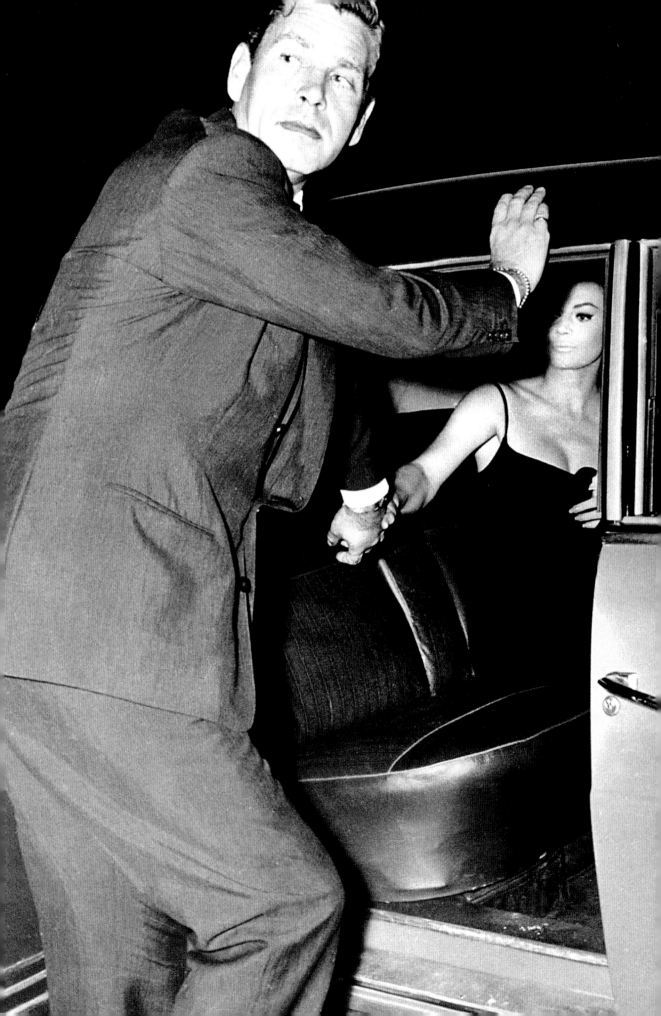

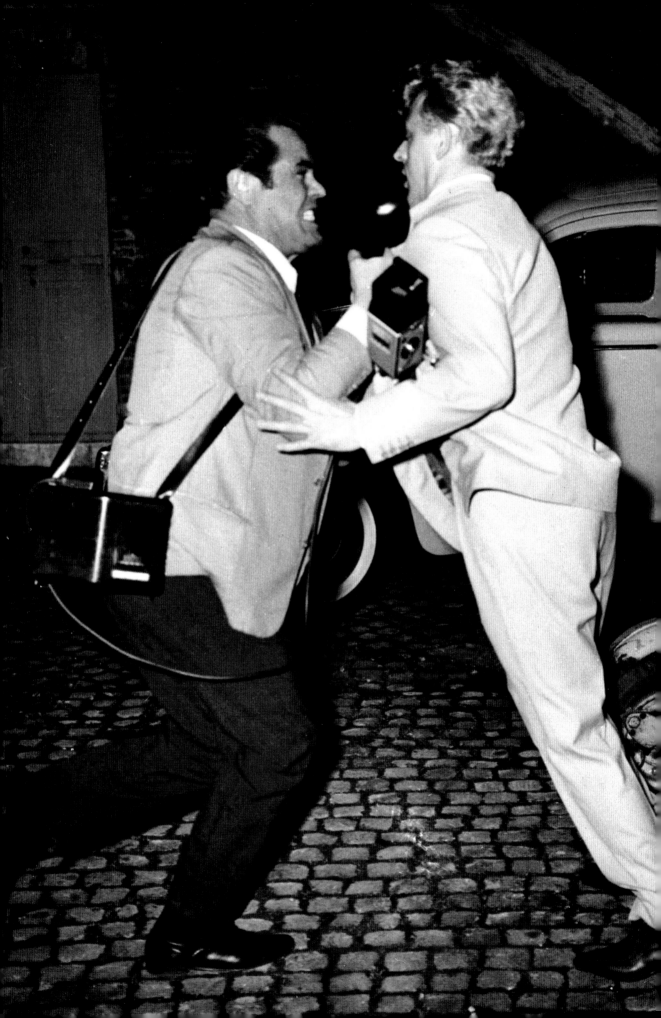

film—trying to attract the photographers' flashbulbs by putting on an outrageous attitude.

The world needs to look down on paparazzi, even if it cannot do without them. From her wedding day to her divorce, Lady Diana Spencer, Princess of Wales, was an object of admiration and a leading figure for the Windsors' publicity. She was even given lessons to this end. She learnt them so well that later on, after her separation and divorce from Prince Charles, she used them to her own ends, and plunged the selfsame royal family into disarray. Even going so far as her televised confessions about her extra-marital affairs. Before becoming a victim as an indirect consequence thereof, after having given her consent. In *La Dolce Vita*, People live and die through their own image too, be it public or innermost. One last reference to 1959. For the very first time, aristocratic Roman families, and in many instances the Vatican nobility, agreed to appear in a film, playing…themselves. For a one-night sequence, which ends with a torchlight procession at dawn, they head for the chapel on the estate to attend ritual mass. An orgy, and a Eucharistic host.

The scene was shot on the vast property of Don Livio Odescalchi. It is a sixteenth century palace located at Bassano di Sutri, 25 miles from Rome, on the Via Cassia. In the scene Fellini mixed extras with actual members of the aristocracy, and directed his entire world as if he were the master of the house.

Nowadays, royal families appearing on celebrity and gossip pages announce the wedding of an infanta of Spain with a TV journalist, of a princely heir of the Savoy dynasty with a French actress. The scions of age-old families marry commoners. And noble young women who are as emancipated as they are titled also get married to commoners. The Grimaldi family of Monaco would have been music to Paparazzo's ear.

So the year 1959 was definitely the end of a world when Fellini filmed *La Dolce Vita* in Cinecittà's Teatro Cinque. In the studio he recreated a

Page 67: Anita and her husband Anthony Steele attempting to shake off the papararazzi.

stretch of the Via Veneto to a tee, between the Excelsior and the Café de Paris—he had been refused permission to film there between two and six in the morning. With just one difference: the Via Veneto actually slopes, but in the studio it was flat. People did not walk down it to hell or up it to heaven; they just survived this platitude…in the here and now.

In a clearing in the pinewoods at Fregene (where the final orgy takes place), Fellini had pine trees planted; he would start all over again in the same spot for the shooting of *Juliet of the Spirits*, starring Giulietta Masina, his wife, who did not feature in *La Dolce Vita*, nor in *Fellini's 8 1/2*—and who felt "neglected" and "abandoned," at least in her husband's films. This is where Federico and Giulietta would before long build their own *villetta* (on Via Portovenere). And it was in this same period that Fellini would decide to build all his sets in the studio. Much to the financial displeasure of his producers. So for him, *La Dolce Vita* ushered in both a eulogy for, but also a war against, the fake; to achieve the truth.

The year 1960 saw the worldwide release of the film, and its triumph at Cannes amidst both boos and applause. There was also a huge party in the upper part of Le Cannet, which could well have been used in the film.

Fellini's film was screened at the Palais with much pushing and shoving. Invitations were sold on the black market. Rossellini was unable to get in, because he did not have an invitation. The critics were split. "Why would you applaud your own ruin?" quipped Georges Sadoul in *Les Lettres françaises*. "This much-awaited film was greeted with a dumbfounded amazement verging on a rout…" Jean de Baroncelli, of *Le Monde*, criticized the film for "its excessive length, its disorder, and its repetitiveness." And then, to cap it all, Anita Ekberg failed to turn up.

The producers were disappointed, but they nevertheless threw a party at the Villa Bénéfiat in Le Cannet. A party "*Dolce Vita*-style," wrote the young Philippe Labro, reporting for *France-Soir*. Did he realize that, for

Previous pages: Left: Ava Gardner caught at the airport. Right: A row with paparazzi on the Via Veneto. The prey here is English singer Wee Willie Harris.

the occasion, he had slipped into the shoes of Marcello, the film's gossip columnist?

He wrote this: "People at the party ate spaghetti (100 lbs. of it) and drank whisky (6/12-bottle cases) and Chianti (250 bottles). And to the strains of "Tea for Two Cha Cha Cha," photographs were taken of young woman in evening gowns bathing in the pool like so many water lilies in a pond. This is a tradition: in Cannes as in Hollywood, if people get together an evening—with starlets round a swimming pool, photographers wheeling around starlets, and onlookers wheeling around photographers—you can be sure that one someone will fall into the pool. All that remained to be known was who pushed the starlet, if anyone did... 18-year-old Jocelyne Janseli, a blonde in a white dress, and Sophie Désirade, also blonde, but in a pink gown, were the first victims. Ten men followed them, at a rate of one every five minutes. Fifteen bottles of whisky had been stored at the bottom of the villa's pool. The bottles were a set-up, all they contained was water."

By daybreak, Fellini had no longer cause to be disappointed by the critics'

Opposite page: A serenade near the Trevi Fountain for Liz Taylor and her husband Eddie Fisher.

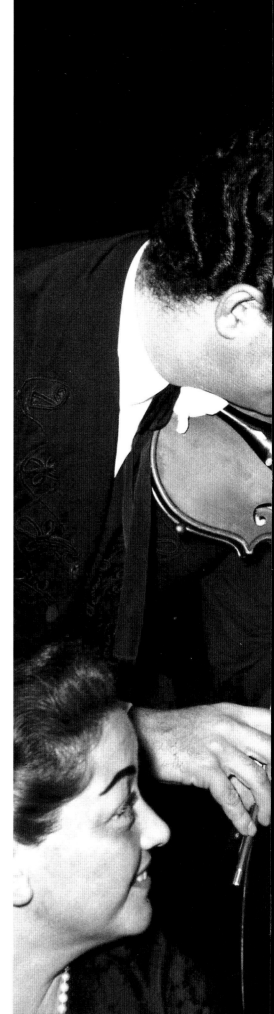

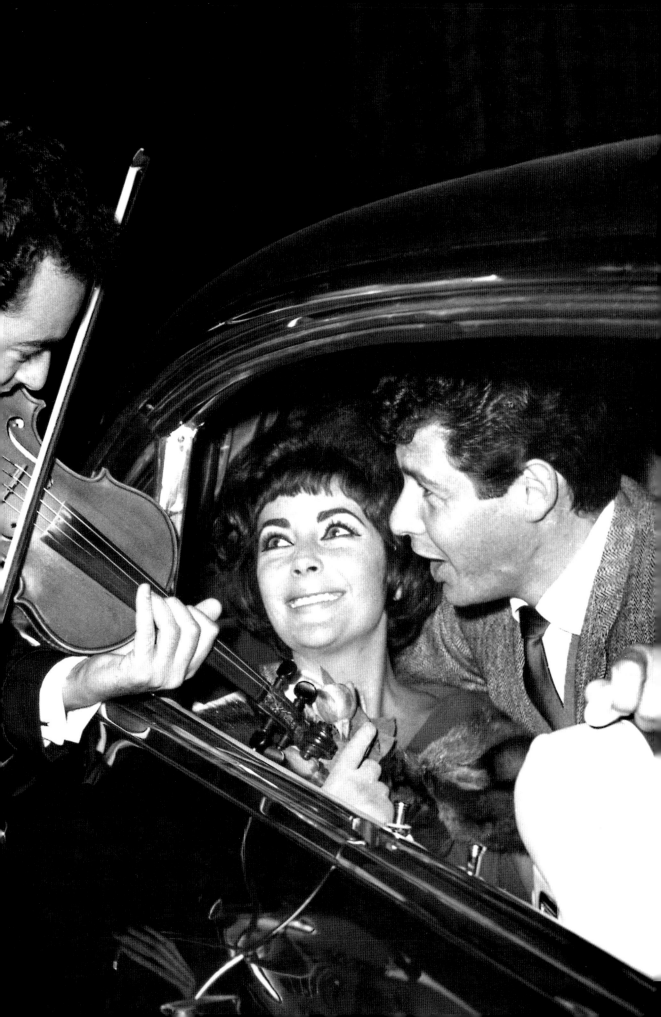

reception of his film: life at the Cannes festival started to resemble his film, and reality started to echo the cinema.

La Dolce Vita walked away with the Palme d'Or, against all expectations, and as the result of much fierce arm-twisting by the jury's chairman, Georges Simenon, backed up by the great American novelist Henry Miller (whose reputation had become scandalous since *Nexus* and *Sexus*). Forever more, this would be the date of the Big Crash (as opposed to the Big Bang) of this world. Thus are myths born, and thus do society and cinema change. Including Fellini's cinema.

A Fellini whom the paparazzi never hounded in his private life. And yet the episode of *La Dolce Vita* when Mastroianni leaves Yvonne Furneaux on the side of the road is directly based on an affair Fellini had with a certain Lea, of San Marino. Lea also attempted suicide.

Although Fellini's hero—and anti-hero—Marcello Rubini had held his father in affectionate contempt, the Roman paparazzo will hold his progenitor and inventor in due respect. And when one of them took a photograph of Fellini on his hospital bed (after he had his first heart attack), no magazine published the snapshot.

Opposite page: Jayne Mansfield in the arms of her husband Mike Hargitay, Via Veneto.

[THE WORLD'S A STAGE]

Every kind of comment has been made about *La Dolce Vita*. For and against it.

With *La Dolce Vita*, the public was invited to share a Baroque vision that was totally new on the big screen. Hitherto, the commercial cinema had never known anything like Fellini's flashes of brilliance, and now this fresco would usher in the years of greatness. As soon as the film was released, commentators argued about the content of Fellini's project: was it a cautionary tale? a disillusioned satire? or a knowing, or at least self-satisfied portrait? In an era saturated with well-defined ideologies, the film was reduced to a social debate. In Italy, the usual champions of so-called traditional values promptly demanded that the film be censored, while the left-wing intelligentsia felt duty-bound to aggressively defend the film.

Rare, however, were those who realized that the real substance, not to say content, of *La Dolce Vita* was quite simply its style. The often-excessive style of the characters, as well as the style of the locations both contributed to the development of an exclusive and glorified atmosphere. Witness the memorable scene in the Caracalla Baths, with the ruins turned into a nightclub. Fellini used style as a dramatic ingredient.

As in the commedia dell'arte, the onlooker immediately situates each Fellini character: accentuated features, sublimated clothes, hairstyles and props. In a nutshell, the whole appearance was shrewdly coded: "You don't get to know the characters in my films as the story unfolds," Fellini

Opposite page: Fashion always under the influence: a make believe film set for *Vogue*.

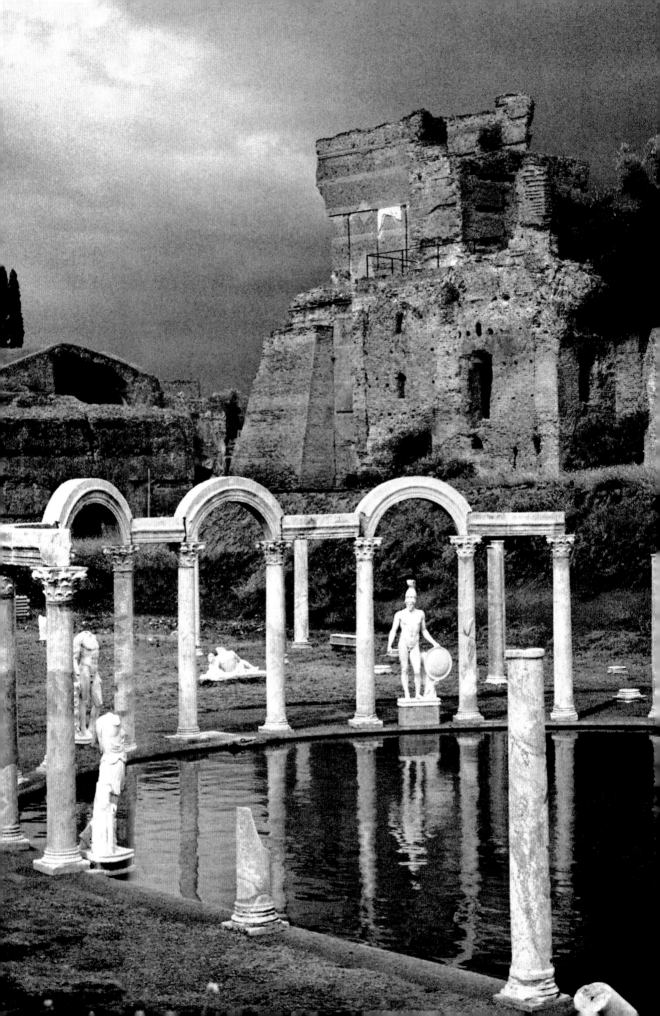

Rome is still
the sumptuous
trace of
a millennial
empire that
collapsed
a long time ago ...
"Federicus
Fellinus" is
the heir to
the antiquity,
which Romans
no longer see.

declared. "Each one of them must instantly express the whole history they contain within them, and by their presence alone. They are masks." For the director, the character is to be taken in the strictest sense: persona in Latin actually means a theatrical mask. Bergman was always well aware of this, too. These inimitable, disconcerting masks—all very precise in the way they exaggerate things—all have something extra. Here, artifice inevitably leads to what is true. Fellini offers us a fine series of unforgettable portraits.

For Fellini, who remained totally faithful to one of the fundamental ideas of Baroque narrative, the world is one huge stage, peopled by human beings who are subject to the laws of performance. He makes no judgment about this state of affairs. But we have to believe that, in one way or another, he likes all that he shows, grotesque and sublime, dancer and clown alike.

Pier Paolo Pasolini wrote: "Fellini's reality is a mysterious world, either horribly hostile, or intensely gentle, and the Fellini man is a no less mysterious creature who lives at the mercy of this horror and this gentleness." Similarly, Fellini's characters play their own lives in the real sense of the term. Some of them—including Marcello in *La Dolce Vita*—seem to be aware of this, and although they struggle between cynicism and amused resignation, they still recite their lines. Others do so swept away by an innate theatricality, and others still by an excess of sophistication. Lastly, there are those—of the fair sex in particular—who, in their perfect innocence, know nothing about this whole role-playing act, which, in a Baroque paradox, does not prevent them from assuming their own role to the fullest.

The adjective "Fellinian" henceforth universally defines the imagination in its most extreme form, and in its most moving or even upsetting form; in the way it illustrates our reality, pushed to its point of fission, as we say about atom bombs.

Previous pages: Emperor Hadrian's Villa in Tivoli.
Fellini will transpose a nightclub onto imperial ruins.

In just one decade, the neorealism that stamped the work of Luchino Visconti, Roberto Rossellini and Vittorio De Sica took on the status of something classical, and, by giving form to a new need for expression, Federico Fellini would regularly draw further and further away, with each one of his productions. So nobody was expecting the conceptual leap he made in *La Dolce Vita*.

The age of *La Dolce Vita* was saturated with ideologies, and there was still censorship—surreptitious, but always on the lookout. Italian champions of traditional virtues (the Church and the Christian Democrats) called for both a ban on and condemnation of what they saw as an apologia for debauchery, while the left-wing intelligentsia (a redundancy of expression), which had hitherto overlooked Fellini or treated him as a minor master—in no way on a par with Rossellini—flared up and saw *La Dolce Vita* as a relentless indictment of bourgeois morality. And rallied to its cause.

"*La Dolce Vita* is a formidable account of the crisis in civilization which, from Italy to the Western democracies, is affecting the modern world," to use the words (written thirty years after the movie was released) of the great film critic and historian Jacques Siclier. "At the end of the dark years of the 1950s—marked by the Cold War between the United States and the USSR, with Germany cleft in two, the Berlin crisis, the Communist oppression in Eastern Europe, the lies of Stalinism and post-Stalinism, McCarthyism and its fascist temptations in the United States, the Korean War, and, for France, the wars in Indochina and Algeria—the European democracies, in the process of toppling over into the consumer society resulting from industrial development, are living in a state of anxiety more or less expressed as an end of the world, caused by a third world war and a nuclear catastrophe." This would culminate in the Cuba missile crisis of 1962.

At the same time, however, in the late 1950s or thereabouts, Europe, which had been destroyed by the Second World War, was rebuilding itself with

Following pages: Rome: (left) children amid the ruins of war, (right) the Palazzo Ruspoli.

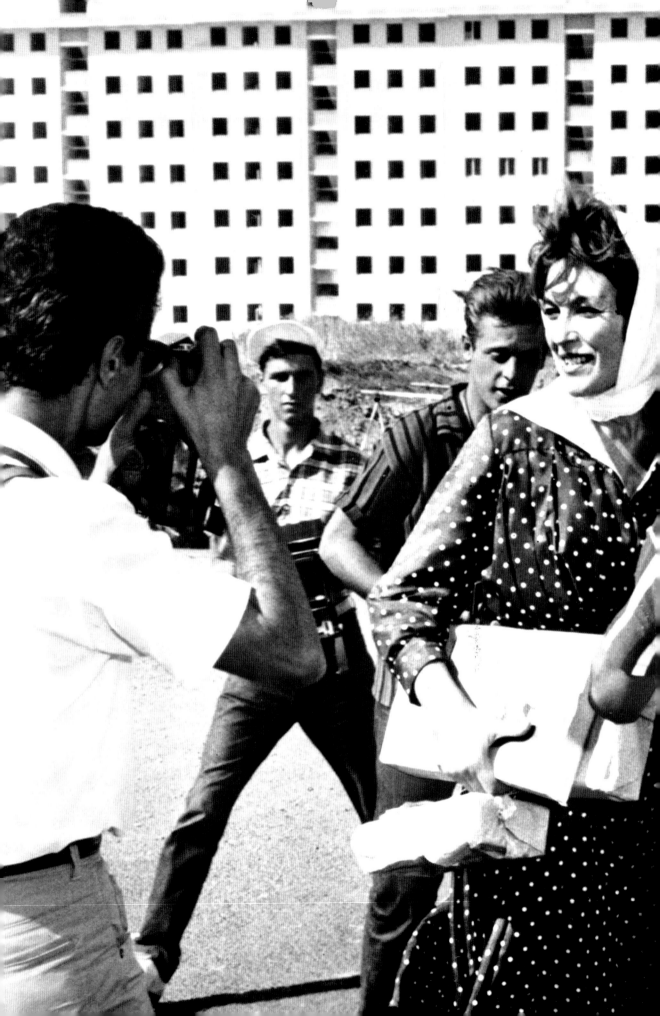

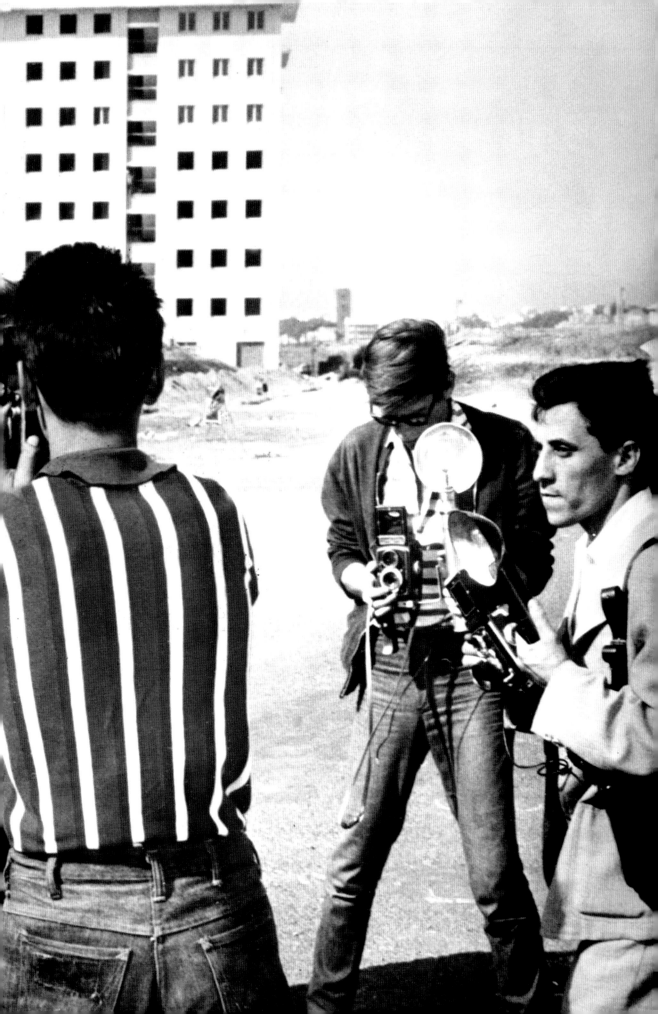

the help of America and the Marshall Plan. In Italy, the Christian-Democrats of Alcide De Gasperi (one of the founders of the European Community), backed by the United States, avoided a "revolution" and tried to manage a country gradually growing richer. At last it was a pleasure to live in Rome. From increased growth to full employment, the famous economic boom then produced its first prodigies. These initial signs of material well-being turned out to be so unexpected that people talked about them as the "Italian miracle." The country was definitely in the fast lane: the nouveaux riches paraded in large convertibles, the new middle classes in Fiat Seicentos, and, those who had no access as yet to credit contented themselves with two wheels. A postcard symbol of this modernity that was accessible to one and all: the young couple sitting astride a Vespa, against a backdrop of working-class neighborhoods under construction. *Belle ma povere*—beautiful but poor—as the title of a play put it; a play, written by Dino Risi, that was a great success in its day. She had teasingly enticing Bambi eyes, a little scarf knotted beneath her chin, and wore a colorful cotton dress; he, a sexy little proletarian, sported a quiff. The radical, irresistible change reverberated through every social milieu. The Marcello of *La Dolce Vita* came from a poor background, and found himself catapulted into the gentry—who, oddly enough, took him in under its wing. The real Marcello (Mastroianni) was the son of simple country folk, and worked in an office before acting in a play directed by Visconti. In his first jobs in film, he actually incarnated a sort of nice, honest and somewhat naive working-class guy. And Fellini was born into a provincial lower-middleclass family from Rimini, and started out…in journalism. Via caricature! He and Marcello knew Italy from the bottom-up, and in the space of one film, would mix it with the Italy of the Via Veneto, acting as a melting pot.

Massive housing estates and factories looming up from land that was until just recently countryside, thus gracelessly marked the arrival of the

Previous pages: The paparazzi surrounding Mrs. Steiner (Renée Longarini),
still unaware of the death of her husband and children.

industrial age in those ancient landscapes. Thus were born the initial symptoms of a consumer society, in its Mediterranean version, of which the Song Festival, held in San Remo by the sea—a resort rediscovered in the shade of royal palms, in a mock-tropical setting, with its Victor Emmanuel-style wedding-cake architecture—is still among the best and forever nostalgic witnesses.

Hollywood stars and producers now burst upon the scene, as we have mentioned, in the Cinecittà studios, and set up shop and home in Rome. There they enjoyed gilded sojourns in the villas lining the Via Appia Antica and in swell apartments with views over the city's splendors, merrily mixing with local young people and their good looks. Kirk Douglas filmed *Ulysses* here in 1954, Mervyn LeRoy came to direct *Quo Vadis*, William Wyler made his *Ben-Hur*; and Robert Aldrich his *Sodom and Gomorrah*. Audrey Hepburn and Gregory Peck burst onto the scene in *Roman Holiday*. But the fashion was more to epics, an Italian film specialty, in which the Lithuanian-born actor Jacques Sernas was a star. This same Jacques Sernas played Jacques Sernas (star of *Helen of Troy, The Loves of Salammbo, The Queen of the Tartars, The Centurion, Duel of the Titans*, and so on) in *La Dolce Vita*. So Hollywood also turned up to hymn antiquity in Cinecittà, twelve miles or so from Rome's forums and the Coliseum. Before long, Cleopatra would be its ruinous culmination.

For it goes without saying that Rome is still the sumptuous trace of a millennial empire that collapsed a long time ago, and the seat of a Church ruled over by the last absolute monarch, the Pope.

A fruit of the purest Roman civilization, *La Dolce Vita* encompassed both these legacies in its own way, which was Federico Fellini's way.

Trajan's Forum is invaded by cats; there are lots of cats roaming around Rome. And the episode with the kitten near the Trevi Fountain is very local color indeed. All Romans are forever going alongside the remains of the city's imperial grandeur, but in this grandeur there was not just Augustus, Marcus Aurelius, and Hadrian; there was also Messalina, Nero, Caligula and Elagabalus. They would not clash in *La Dolce Vita*, but they would divert the

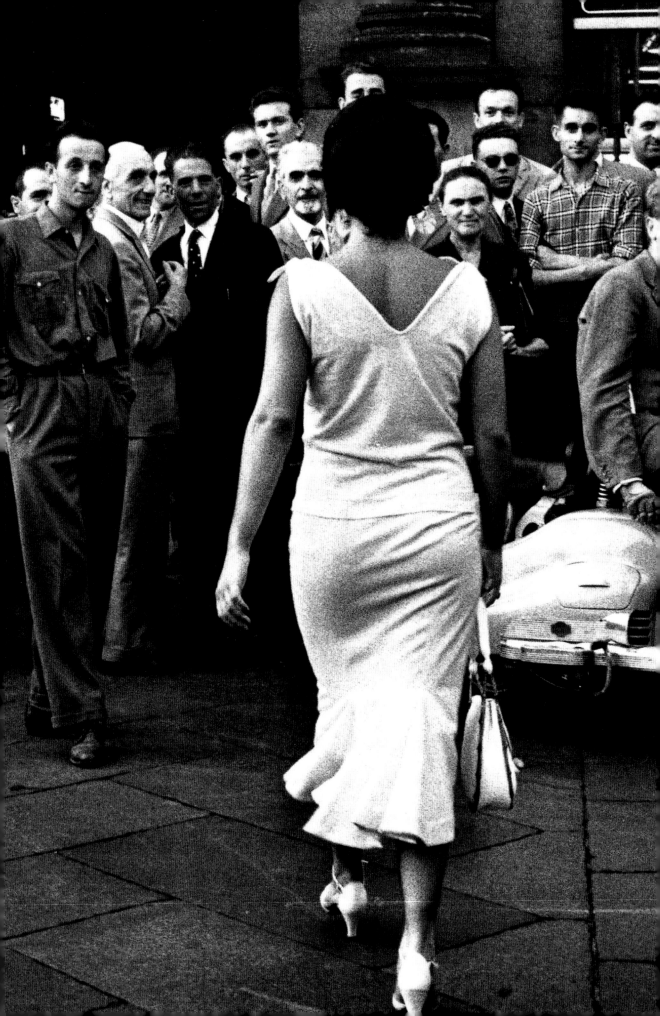

film toward vice. This was not Fellini's intent. He never muddled liberty and debauchery. The debauchery he depicts is shown in the name of freedom. Freedom of thought and, it just so happens, freedom to show things.

In fact he does not judge, nor does he demonstrate... Let us say it again: he shows. And what he shows is profoundly human. But "Federicus Fellinus" is the heir to the antiquity, which Romans no longer see because it is so present all around them. He would turn this Rome into an emotional masterpiece in *Fellini's Roma*. When the subway train comes out onto a buried Roman villa and uncovers its walls painted with wonderful, delicate frescos—whose hues are erased while, with the sound of a mighty wind, the polluted air of our day wafts in—there is not a dry eye in the house. But this was also a reminder, by way of the disappearance of the ancient art of painting, constructing and living, of the vanishing of the world of the 1950s—the years of Fellini's own creative youth. A tender little wave, while Rome became modernized (with the metro), at the Rome that had vanished many centuries ago, and the

Opposite page: Rome and its everlasting Romans... Men ogling a *ragazza*.

The beloved movie star
in a long dress takes off her
pumps and slides into the water
of the Trevi Fountain. It became
the model of freedom of
expression ... Fellini created
a fresh way of being that would
inspire not only the avant-
garde of cinema, but also
advertising and fashion. ...
He also opened the way
for the eruption of the 1960s,
when living a "Dolce Vita"
took on a London spin,
with insolent youth rebelling
again the "old world."

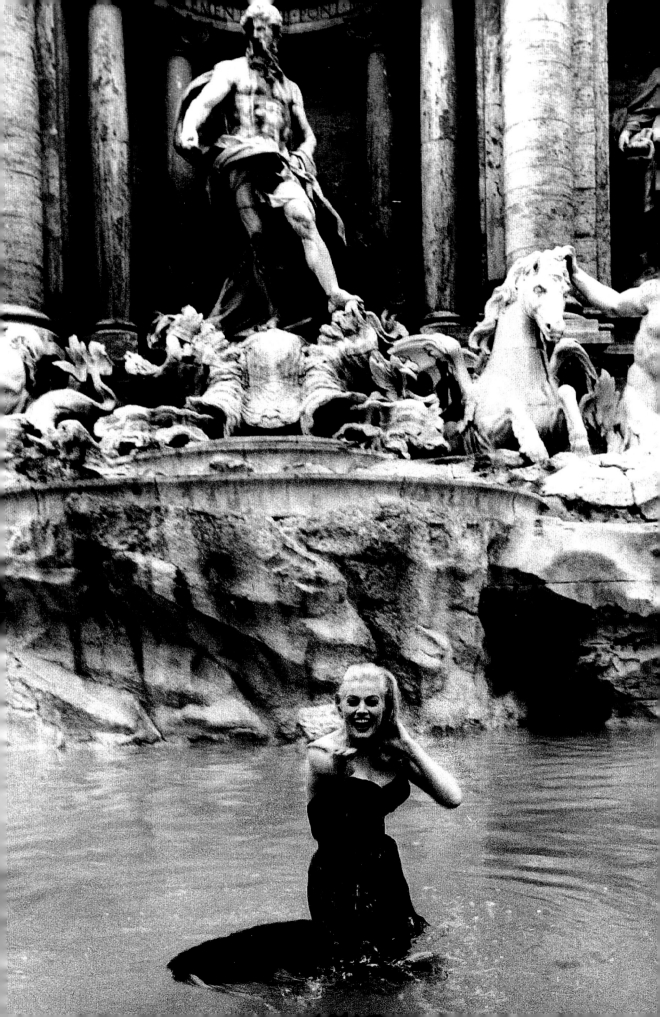

Rome that was disappearing in 1960 with *La Dolce Vita*.

Antiquity is present in *La Dolce Vita*, but the superb Caracalla Baths have become (albeit only in the film) a nightclub where Anita Ekberg turns on the party animals with an extraordinarily lascivious dance, which is either applauded or reviled. The film's other great dance, Nadia Gray's striptease, would be every bit as lascivious, but without the joie de vivre of an American star having a ball—a dance that is as scandalous as it is sad.

Fellini would also draw on this ubiquitous antiquity for his *Satyricon*, based on the work of an intellectual aesthete from the reign of Nero, Petronius—his full real name being Petronius Arbiter, because he is an "arbiter of elegance."

A decadent fresco? Certainly not. Rather a poetic vision inspired by a world prior to sin. Fellini's forms of elegance are moral and aesthetic. He was a true Roman, even if he was born in Rimini.

Previous pages: The original and immortal scene.
Another *Birth of Venus*.
Opposite page: Fellini's paradise:
the Teatro Cinque at Cinecittà.

[PERMANENT SCANDAL]

This world-before-sin of the *Satyricon* is, needless to say, the world before Christ. Christ whose "large dark silhouette" (*grande sagoma scura*, in the screenplay written by Fellini) flutters over the areas of waste ground on the edge of Rome near the ruins of the Felice aqueduct. The god made by man falls from the sky before the very eyes of Marcello the disenchanted. Here, it just so happens, we have the shadow of a possible salvation.

"I'm not in the habit of going to church," Fellini admitted to Damien Pettigrew, "unless I'm in some kind of major moral crisis, but when I go into a church, it's because I'm curious about the décor, the paintings, and the architecture. It's very dark inside churches, and I find that irresistible."

"Unless I'm in some kind of major moral crisis." And when it is the world he is filming that goes through this crisis, what then? What does Federico Fellini do?

He dresses the generous curves of a big star like Anita Ekberg in a sexy adaptation of an ecclesiastical cassock (well done, Piero Gherardi!), which hugs her wondrous figure. And it is this creature who creates havoc among the journalists, including Marcello, who is out of breath and already a bit weary and disgusted after dashing up the 700 steps which lead to the dome of St. Peter's of Rome.

Benetton, for his part, will get a nun and a priest to kiss, both duly cassocked, in one of his advertisements.

Blasphemy? No, this whole scene bedazzles like a smile, an innocent prank by a schoolboy in a religious college. Each one of Fellini's religious

Opposite page: The final orgy, just before disenchantment.

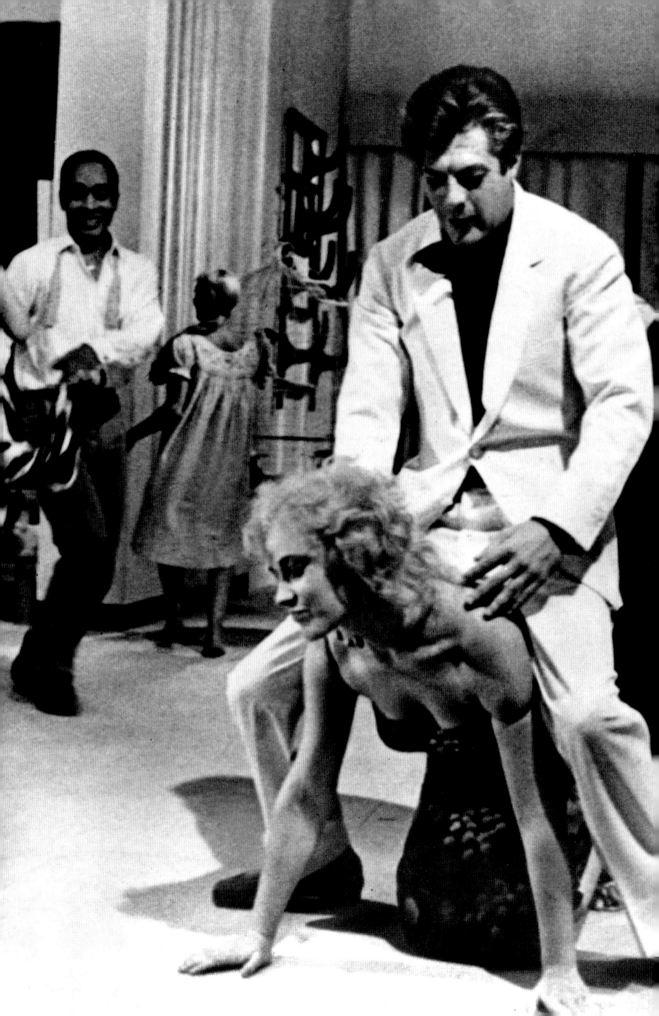

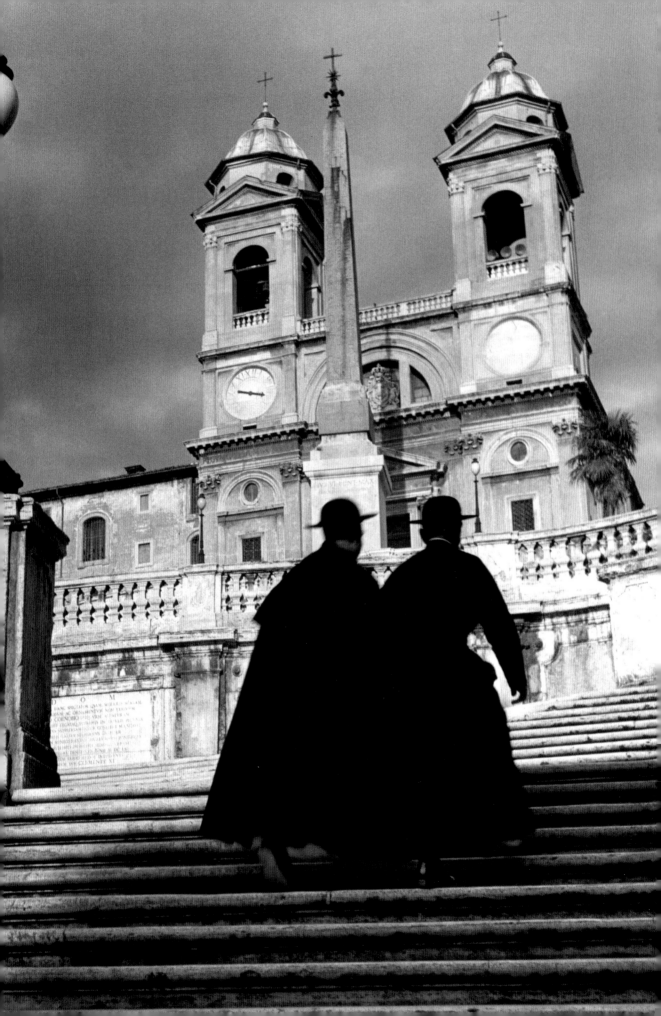

evocations is tinged with this at times bitter smile (the bogus priest is the petty crook of *Il Bidone*); but it is a self-conscious smile, meant to keep a private and mysterious character in all beliefs. Self-respect, and respect for others, in a way.

Fellini sows confusion in people's consciousness, be it his audience or his characters. Marcello is on his way toward a kind of at once unwholesome and radiant pleasure in his journey to the end of the seven nights. He displays the elegant but ambiguous nonchalance of an investigator although he is also involved in those nights (he orchestrates the final orgy, half disgusted, half in cahoots). To use the pretty words of the critic Gilbert Salachas, borrowing from Brassens, "he will murmur sweet nothings to beautiful damned souls."

The seven nights of *La Dolce Vita* are lit by the dark sun of the death of the soul. With no redemption.

The Vatican disapproved of it; the beautiful souls screamed. "Display of turpitude!" People spat at Fellini and Mastroianni in Rome and Milan. "Good-for-nothing, coward, pervert, communist!" Catholics who went to see the film were threatened with excommunication. The Vatican, Catholic Action and Cardinal Ottaviani, prefect of the congregation of the Holy Office, all launched a violent campaign. Pope John XXIII had approved the screenplay but, in the course of a private audience, he denounced "artists who, under the cover of freedom of expression, produce unscrupulous works."

Several interpellations were addressed to the Parliament demanding that the film be banned, but the Secretary of State for Tourism and Spectacles, the Right Honorable Domenico Magri, replied with a no: "In Italy, the art of the cinema must not be stifled by censorship."

The Catholic office of the Italian cinema deemed the film to be "morally unacceptable" and forbade the faithful to see it. As did the Association of the Dioceses of Roman Catholic Action. And an article in the *Osservatore*

Previous pages: The image of cassocks climbing the Spanish Steps to the Trinité des Monts were re-used for Anita, and later (on the right) for a fashion show by Milanese designer Krizia (Spring/Summer 1991 collection).

Romano would be written (but not signed) by Oscar Luigi Scalfaro, future president of the Italian Republic.

The characters in *La Dolce Vita* in no way proselytize for any vice, they simply show the sincerity of the damned: they rebuke each other out loud for their vices and villainy, but nothing comes of it. Here, there are no tears like those of that brute Zampanò at the end of *La Strada*, but the tired face of Marcello, ravaged by sleeplessness, not hearing the call of the young blonde woman from the other side of the monster beached on the strand, the side where the real world is.

"You'd have to be deaf and blind not to see and feel the huge desire for salvation that underlies the film. What did people want of my characters? That they proclaim their repentance for all to hear? A person who's about to drown doesn't shout about his repentance, he shouts for help. My whole film is calling for help. And if this cry is not heard, it's not my fault, and nor is it my business."

"I don't know why certain Catholics disapprove of my film. But I know why some of them approve of it. They approve of it because it's a Catholic film. Someone wrote that I observe my characters 'with love.' He's quite right. But it would be more to the point to say that I observe them with Christian piety."

This is the opinion of Cardinal Siri—who, with John XXIII growing older, looked like a possible papal candidate but was beaten in the final ballot by Cardinal Gianbattista Montini, the future Paul VI, archbishop of Milan and very much in the anti-*Dolce Vita* camp—and of the Reverend Jesuit Father Arpa, for example.

Some had accepted a neo-realist Fellini (in his own way, and there would be things said hereupon) for *La Strada* and *Nights of Cabiria*, where poor, lost characters, with no apparent qualities, were suddenly touched by God's grace, and earned a kind of redemption in death, with Giulietta Masina playing the role of the redeemer. But what most could not

Following pages: The final orgy: Nadia's striptease.

I don't know why certain Catholics
disapprove of my film.
But I know why some of them approve
of it. They approve of it because it's
a Catholic film. Someone wrote that
I observe my characters 'with love.'
He's quite right. But it would be more
to the point to say that I observe
them with Christian piety.

accept—and this "most" encompasses a large part of the Catholic and the aristocratic worlds, which nevertheless agreed to appear in this film— was that Fellini, a Christian moralist by his own avowal, revealed the spiritual and ideological emptiness of a world, their world, the Western world. They understood that *La Dolce Vita* is the film of the Apocalypse, of the Apocalypse here and now. And that it could have been titled, as another film would be in due course: Apocalypse Now.

The critics went on the rampage—which is what they are paid to do—but so did the censors. The battle and the debate may have occurred in the written press, but the audiovisual realm was barred to Federico.

"I'd asked to be able to talk about my film on TV. I wanted to clear up the ambiguities, and put some order back in the polemic. The program director refused to let me speak. For our television, any criticism of the Church is tantamount to inviting a veto."

Federico did not know the period in which the Berlusconi TV empire would be in full expansion... But from *Ginger and Fred* to *Intervista*, Fellini took his revenge, and got his own back on Italian television—and with what talent and what joyous ferocity!

"I accept discussion at an artistic level. Everyone's free to think what he or she wants. But I'm against those who use this discussion to obtain a moral condemnation. I categorically reject the idea that my contemplation of vice is indulgent or self-satisfied. I won't put up with 'rhetoricians' of sexiness getting up in arms. And it really saddens me that there are so many people who applaud guardroom vulgarity, but condemn a discourse that's sincere. I'm talking about certain cultivated people, and certain hypocrites who have a whole life of depravity behind them, but come across today like model family men.

At times I just laugh, and leave it at that. But when people rebuke me for treating my country with contempt, I can't laugh any more. It's really sad, this caricatural defense of values which no one believes in any more."

Opposite page: A journalist, some transvestites, a blond...

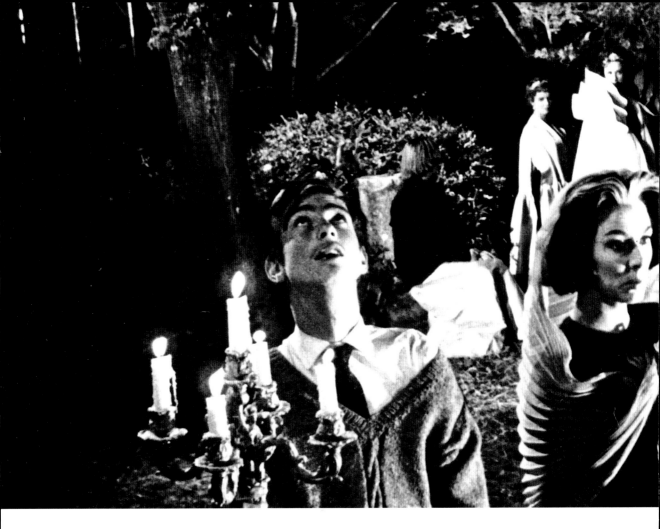

Nothing has changed; all you have to do is see Nanni Moretti's *Aprile*, a kind of sequel or "fugue" in the musical sense to his *Caro diario*, to realize that with *La Dolce Vita*, Fellini experienced what Moretti wittily described later: the political power grabbed by "Sua Emittenza" (a popular nickname for Berlusconi), master of Italian television (and now of the written press, too), and the difficulties encountered by a gifted director to create a simple musical comedy about "the life of a Trotskyite confectioner and pastry cook."

We can thus understand how a live report on the apocalypse in an artificial and almost monstrous world of well-born and highly-placed masks managed to trigger a wonderful scandal. As powerful in a different way as the damp squid that greeted Virginie Despentes' *Baise-moi/Fuck Me*, and the unbearable *Irreversible* by Gaspar Noé. This latter film

Above: A soirée in the aristocracy: at dawn, one goes to the chapel.

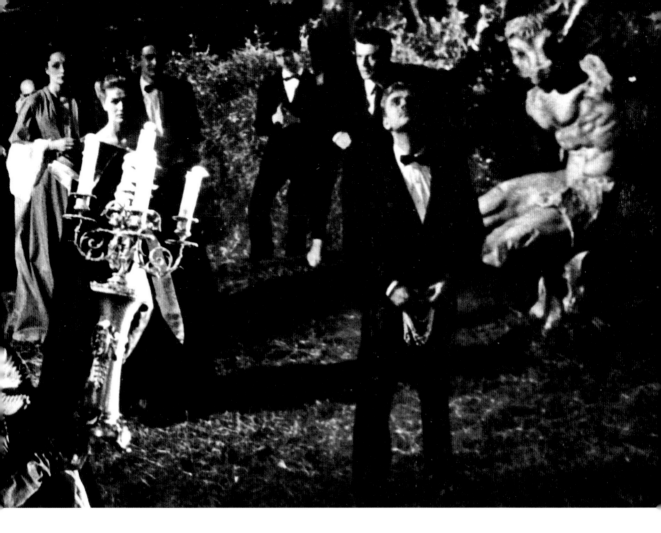

nevertheless starred Monica Bellucci—also a super sexy spy of the Vatican in *Le Pacte des Loups* (Christophe Gans, 2000). Her sensational beauty would have delighted Fellini.

Although the hero is a journalist, *La Dolce Vita*, with its Baroque wonders, is a pure report about reality at the moment when this reality becomes hallucinatory.

The best example of this is the "night of the Madonna." Here, there is no cute Via Veneto world, but rather the whole of Italy: the rich, the poor, the intellectuals and ignoramuses, the young and the old, the sick, the children. A cute cross-section from top to bottom of Italian society. A slice of Naples where the working-class Rome of Trastevere rubs shoulders with the Via Veneto crowd.

"It would be a mistake," Fellini warned, "to give my film a social meaning. It is possible that superstition is a characteristic of certain classes, but I had something else in mind. The dominant theme of my

film is one of expectation. I wanted to emphasize it by the expectation of a miracle. From this angle, rich and poor are equal. Marcello and the worker, the painter and the bimbo: all run to the spot where it is said the Madonna will appear. They all run to ask her: 'Tell us, Madonna, tell us the meaning of our life, and the purpose of our waiting.' But it is a phoney miracle, and the waiting goes on."

Children are impostors dragooned by their parents to collect a few lira. A priest from somewhere else rails against the hoax. But this does not stop cameramen and photographers from taking endless snapshots of children on knees and adoring…nothing. A void. They film and photograph nothing, just as Emma prays on her knees. And everyone will once more be equal in the torrential rain. Why not a deluge before the apocalypse? The children play at believing the way Marcello and his high society chums play at living. Each instant of *La Dolce Vita* illustrates this concept. In 1959, not only did Fellini guess at the imminent fate of rich societies, which would intentionally turn into societies of the spectacle, but he also deciphered the mechanisms that lead there, and, disillusioned, foresaw its pernicious effects. Among a thousand other things, one grasps the cautionary tale that *La Dolce Vita* is: how and why our culture has managed to demean itself right down to the mediocrity of reality TV.

But in the pure Baroque perspective, which is the one adopted by the film, each image is the same as its reflection. Reality and illusion operate in an ongoing transfer and go round and round in a continuous loop: from reality to illusion, and from illusion to reality. The Madonna scene, where the press organizes a real staging around the fake miracle, is thus a perfect example of this.

This nook of countryside (at Bagni di Tivoli, where Marcello's father also meets Magali Noël) is an outdoor studio. It is another truth, different from the religious truth mentioned earlier, which comes to light here: it is a cinematic truth. The children who are supposed to have seen the

Opposite page: A "dolce vita" soirée. Tazio Secchiaroli, the image chaser, immortalizes a striptease. Very bold for the time; the photo reportage created a scandal when printed the following day on the front page of the *Corriere d'informazione*.

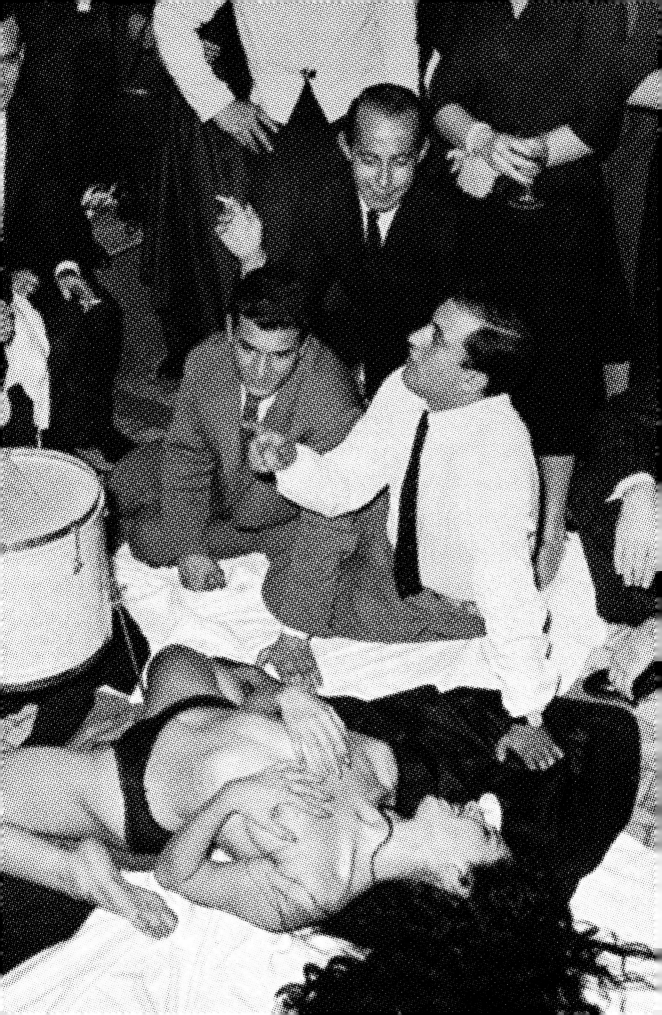

Blessed Virgin may well be mediocre actors, but by its very presence the crowd (the audience of viewers) validates their performance. The journalists aim their cameras at each of these deceitful children as they kneel down, taking turns. The cassock-clad priest who rails against the hoax into the mikes is a critic who is not heeded, while, in a jolly atmosphere, the sick, the invalid, and the handicapped, brought there in the ultimate hope of a miraculous cure, all revolve. The confusion during the storm, when the paparazzi continue to streak the darkness with their flashbulbs, is the equivalent of walking up the steps at the Cannes Film Festival: a civilized version of the paparazzi's chase. The way they take photo after photo may seem disconcerting to us, and, plunged as we are into the society of the spectacle, a pretty bad omen. And yet the flashes of their cameras hypnotize us and the choreographing around their prey delights us. The whole of Fellini's art lies in the way he puts us in front of our own ambivalences, while also describing those of the world to us.

Opposite page: The Roman soirée at the 1960 Cannes festival. A starlet, a swimming pool, a midnight dip.

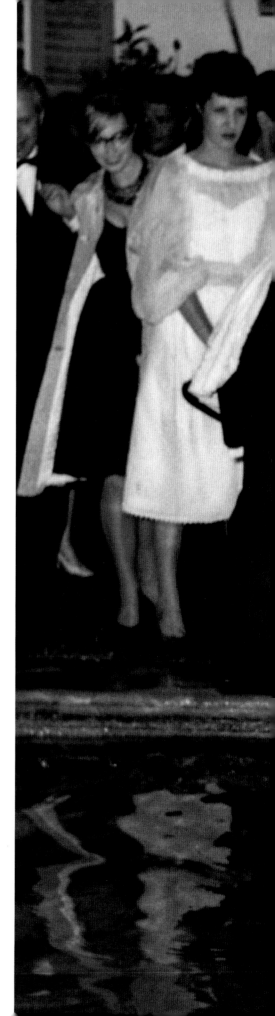

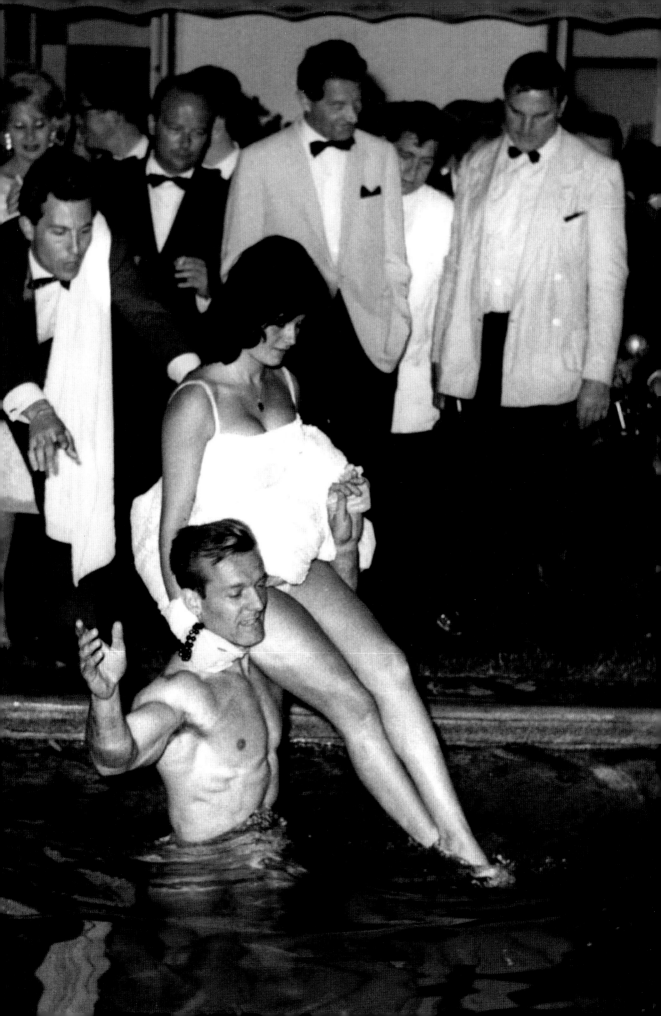

After scandal came success. Two cinemas screened the film in Rome—
La Fiamma and La Fiammetta. The attendance rating was over a
hundred percent, which means that some moviegoers watched the
screening standing. Additional screenings were organized in the morning.
This success is underlined in *Divorce Italian Style* (with Mastroianni), in
which Pietro Germi shows the arrival of cinema in a small Italian town.
The whole village turns up to see the movie, with everyone bringing
their own chair. And it is the audience whom Germi films; the only sound
to be heard is the dialogue between Ekberg and Mastroianni.

In *La Dolce Vita* everyone can see himself, as long as he is looking for it.
Everyone can play at finding who he or she is.

It is tempting to say that, forty years later, the character of Steiner (Alain
Cuny) is undoubtedly the one closest to the viewer. Of course, the said
male viewer is tempted to identify with Mastroianni for his
handsomeness, his disillusionment, his elegance, and his performance as
an actor, needless to add. And also because Fellini finds in him his own
double. A double that will blend with the Maestro's total crisis of
inspiration to produce the extraordinary *Fellini's 8 1/2*. In this movie,
Guido (Mastroianni), a director with a complete mental and creative
block, could well be the Marcello of *La Dolce Vita* finally managing to
forsake gossip for creativity. It is nevertheless Steiner who, on his first
appearance (the reception in his own home, among the family)
represents a form of normality in this adulterated world.

So he commits suicide, after having taken with him the two children
whom he literally loves to death.

And what are the last words that Marcello hears from his great friend and
role model? Here they are. Steiner and Marcello at the door of the
children's room; they have been woken up by the party and their father
has taken them back to bed. They are asleep, with a breeze blowing in
through the half-open window, causing the gauze of the mosquito nets

Opposite page: At the same soirée, a better behaved—but still very Fellinian—Magali Noël.

over their little beds to flutter. Steiner talks quietly: "Sometimes, at night, this darkness and this tranquility weigh on me. It's peace that I'm afraid of. Maybe I fear it more than anything else. I get the impression that it's only a guise, that it's hiding something. Sometimes I dream about what my children will see tomorrow. People say that the world will be wonderful. What does that mean? All it takes is for a hotline to ring to announce the end of everything...or else you'd have to move outside of passions, beyond feelings, in an order that is the order of the work of art. An enchanted order. We'll have to get to the point of loving each other outside time, detached..."

Marcello is dazzled, he does not understand that this is a self-condemnation. Living within the order of a work of art... They all live in it, they live in *La Dolce Vita*. It will kill them, or drive them to despair.

Steiner's role caused Fellini to hesitate for a long time. He thought of having his part played by Enrico Maria Salerno, who had just been highly acclaimed for his role as a Fascist in Valerio Zurlini's *Violent Summer*. At the same time, he was thinking of the French actor Alain Cuny, who had been outstanding in Alessandrini's *The Red Shirts*, Malaparte's *Forbidden Christ*, and Michelangelo Antonioni's *The Lady Without Camelias*. His diction, with its extremely refined phrasing, intrigued and almost fascinated Fellini. And then Steiner is a foreign name, possibly dating from the period of the Austrian occupation. So why not a Frenchman? Although Cuny had played Claudel in Jean-Louis Barrault's troupe, and in spite of his leading role in Marcel Carné's *The Devil's Envoys*, he had never made a breakthrough in French cinema. The only exception had been his part in Louis Malle's *The Lovers*, and anyway, he was happier filming in Italy.

And then Fellini knew that Alain Cuny, who studied fine art and was a student of Charles Dullin, was very keen on psychoanalysis—a discipline which he himself had just discovered with Dr. Ernst Bernhard—and was still a disciple of Jacques Lacan.

What decided Fellini—after having Cuny recite the entire part—was a remark made by Pier Paolo Pasolini (who helped Fellini to find Rizzoli to

finance *La Dolce Vita* after De Laurentiis backed down): "Alain Cuny is like a Gothic cathedral." We hear this comparison again from the painter at the reception at Steiner's home.

The choice was an excellent one. Cuny's stature and phrasing took the role to new heights, but retained all its ambiguity. Who really is this man who has got everything it takes to be happy, but prefers the sounds of nature, caught on a tape recorder, to the voices of his contemporaries? Why does such a fine success (especially in the eyes of his friend, the spineless and disenchanted Marcello Rubini) lead to Steiner's suicide and the murder of his children?

Fellini offers one interpretation: "The Steiner episode has a precise explanation, even though everyone can explain it as they see fit. Personally, if I was a viewer, I would explain the Steiner case as follows: he's a man who can no longer bear the tension of this age of transition; he's a man who can't stand time spent waiting, in expectation, be it with regard to himself, or his nearest and dearest; a misfit, perhaps a weak person. This tragedy must make Marcello and the audience both feel that they're walking on the edge of an abyss, and that our 'sweet life' is verging on catastrophe."

It is interesting to see that the choice was unwittingly perfect. At Cannes, in 1960, the year when *La Dolce Vita* won the Palme d'Or, there were other prestigious films in contention: Bergman's *The Virgin Spring*, Luis Buñuel's *The Young One*, and Michelangelo Antonioni's *L'Avventura*. On the night Antonioni's film was screened, Alain Cuny created an incident with some perfectly "Steinerian" behavior. A dinner for two hundred and twenty people was given at the Palm Beach by Cino Del Duca. Philippe Labro, once again, described what happened in *France-Soir*: "On the dance floor in front of the tables each seating six, decorated in blue and white, with the colors of Mrs. Del Duca's racing stables, the singer Dario Moreno was just finishing 'Le Marchand de bonheur/The Happiness Monger.' Everyone clapped. Then he started on another song, 'Bonjour chérie' … fidgeting and moving his hands, legs, head and mustachioed face, as was his wont. At that moment, Alain Cuny, who was sitting in the front row of the tables, got up,

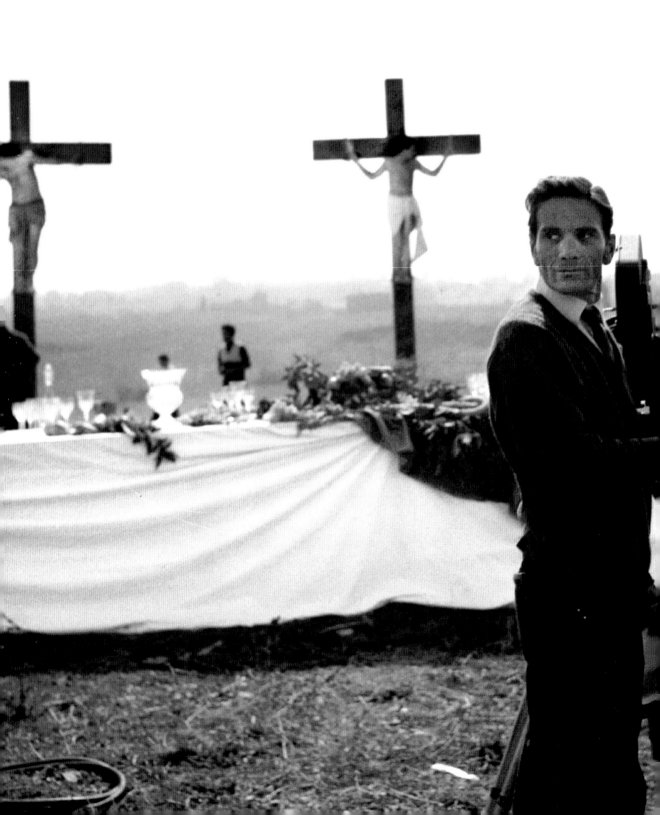

interrupted Dario Moreno, and shouted: 'Shut up! You're a buffoon! ... After a film as wonderful as this evening's [*L'Avventura*], you ought to be ashamed of singing such nonsense!' Adding: 'Dario Moreno, you're the slippery fish in *La Dolce Vita…*'" For a long time, the extremely posh gathering attending the Cannes festival, took this real and sincere anger on Alain Cuny's part as a publicity stunt for the Italian selection. Isn't that all very "dolce vita"? This Baroque film is like a report about a faraway civilization, which is actually our reality. One in which we sometimes act like mad people.

Nothing budges between the film's beginning and end; if the world changes, humankind is static.

Except for Steiner, the only character who stands above the dolce vita, above Marcello's incoherent life. Except for the young woman working as a waitress in a beach bar to pay for her studies. One renounces the "modern" world and the world to come, while the other, called an angel, has her feet firmly on the ground. She'll make out. She's a woman.

Opposite page: Pasolini,
the other scandalous one, on the set of *La Ricotta*.

[CITY OF WOMEN]

"For me, woman is the representation of the eternal principle of creation… I'll find another cliché tomorrow, but will that do for today?"

Fellini's slightly shrill voice thus assails his interviewer Damien Pettigrew in *Federico Fellini: I'm a Liar*. Fellini has his share of propriety. He lived fifty years with the same spouse. They had a son, who died when just a few months old, but no other children. Fellini films women but rarely talks about them. He chooses them, films them, and moves on to the next movie. At times he takes on the same actress again. This is his form of amorous tenderness.

His friend of forty years ("because Federico lived in Rome and I in Milan"), the journalist Tullio Kezich, reveals one or two of Fellini's female secrets in *Federico Fellini, His Life and Films* (Feltrinelli, 2002). Interviewed

Opposite page: The finale of *Fellini's 8 1/2.*

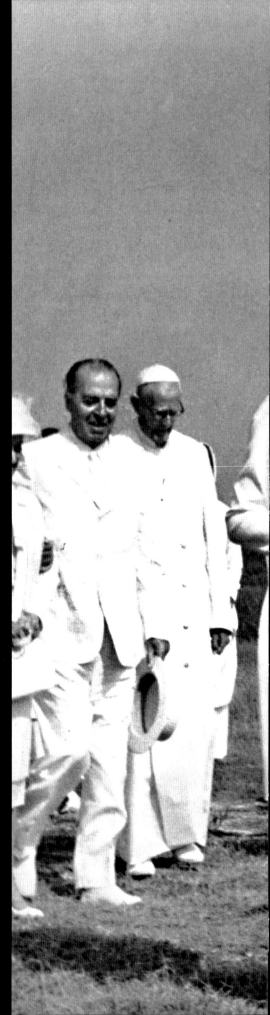

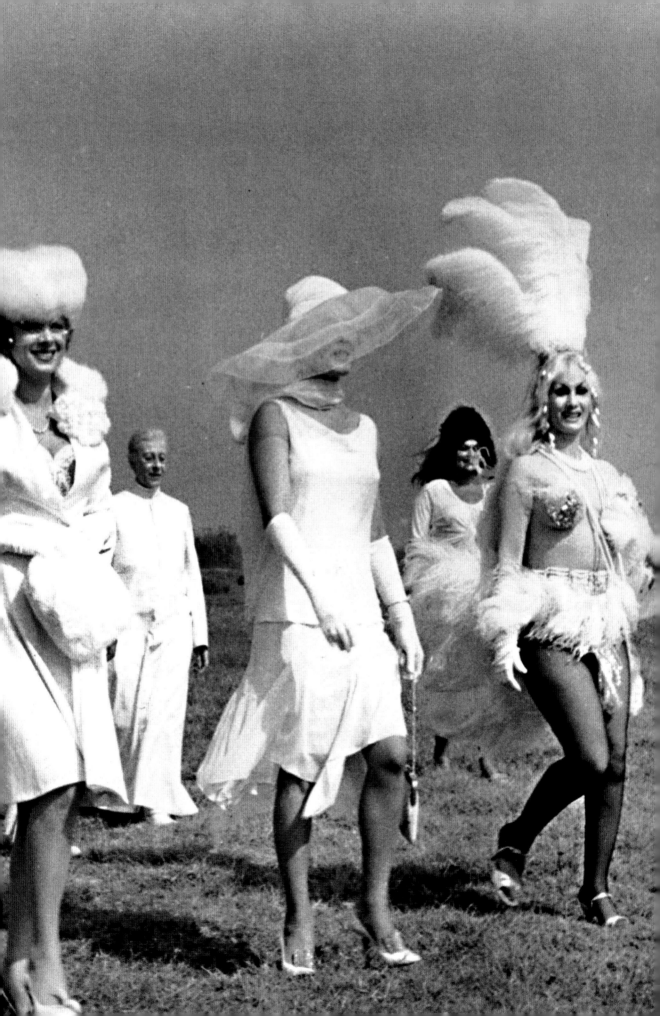

in *L'Express* by Vanja Luksic, for the Cannes Film Festival and their 2002 tribute to Fellini, with its large poster proclaiming "Viva il Cinema" (Fellini's last words, when he received the Palme d'Or in 1960, to both applause and jeers) he also explained:

> "*Juliet of the Spirits* tells about a serious conjugal crisis with Giulietta Masina. She already had complexes enough, and suffered from not being as beautiful as the other actresses of the day, such as Sophia Loren and Silvana Mangano. At the age of about 40 she went through a very tricky moment. Federico was at the height of his glory with *La Dolce Vita*, and he had lots of opportunities … One day a jealous Giulietta had him tailed by a private eye. He talked about all this in Juliet of the Spirits.
>
> *And did she agree to play herself?*
>
> Yes, which is quite extraordinary. He asked her, and she agreed. But each one of them saw the film in their own way. For her, it was the story of a women deceived by her husband. For him, it was something quite different, with its apparitions and spirits… He was completely gripped by the imagery. This is perhaps why the film is not really successful. But the character of the husband, with his self-mockery, is fantastic.
>
> *What was Fellini's real relationship with women? His marriage did hold together for half a century, until his death.*
>
> This is actually very rare in the world of cinema. But Federico had a very orderly side. In his own way he was very faithful. He had a lot of fun with women, but it was never anything very serious. He really did have only one woman in his life, and her name was Giulietta Masina. He lived with her for fifty years, and they made several masterpieces together: *La Strada*, *Nights of Cabiria*, *Ginger and Fred*, and *Juliet of the Spirits*. He called her ten times a day on the phone. They were very different, but amazingly complementary. Federico had masses of little affairs. They were diversions. He loved having

rendezvous and gave the impression of being head over heels in love. He talked a lot and did little, in my opinion. He often used the phone, especially at dawn, because he was an insomniac, and this helped him to become a voracious reader. In this respect, if he liked a book—he read a lot of young Italian authors—he was quite capable of calling the author at 7 a.m. to tell him as much!

He was capricious and whimsical, After a while he would get weary and irritated when the object of his infatuation imagined that this was her great love. There's a whole literature written about this. Some fifteen books have been written by women who all say that Federico was ready to leave Giulietta for them, but they all turned him down. God knows why!

In particular the actress Sandra Milo…

What a liar she was! She did something heinous. She wrote a more or less pornographic book about Fellini and left it with the concierge at Via Margutta, with an affectionate dedication for Giulietta. I remember Federico calling me, beside himself, and asking me what he should do. I told him to do nothing, above all. The book was not at all successful, in fact. Luckily!

I should say that Italian newspapers, even the most scurrilous ones, were always very respectful toward Fellini. He was popular and people left him alone. Thus it was that it was only after his death that we got to know that he had a lifelong friendship with a certain Ana, whom he had been in love with in his youth. For forty years, while he was still seeing her, he never talked about her to me, nor did he to Marcello, who was furious when he learnt about this secret love through the papers. "And to think that I told him everything, all my adventures, all my *pasticci* (messes)!" Mastroianni lamented.

The *pasticci* experienced by Marcello Rubini in *La Dolce Vita* were derisory. Fiascos would have been Rome-lover Stendhal's word for them.

How could a star like Sylvia fall for a journalist's charms? How could a journalist hope that she might succumb? Why would the daughter of a millionaire, the disillusioned, neurotic Maddalena, want to ask a "loser" (all journalists are losers, quoth Balzac) to marry her as she flitted from room to room in a sixteenth century palace, playing with the echoes of an architectural acoustic wonder. She hardly relaxes when she goes to bed with him in the grotty little room they rent from a whore. And she gives herself straight away to another man, after asking him to marry her. So these transgressions are derisory, too.

And hope is too young in a world that is too fragile and grotesque. It is filled with human beings who seem to be the last survivors of an incomprehensible catastrophe, and who think they are existing through the insolence of their behavior. Obligatory non-conformism, and permissiveness seem to them to be freedom when in fact, they encompass an underhanded return to the moral order. May 1968, which jolted the (Western) world from

Opposite page: Fellini and his fantasy women from *Fellini's 8 1/2*, logical continuation to *La Dolce Vita*. Following pages: In the style of… Elsa Martinelli (left) and Sofia Loren (right).

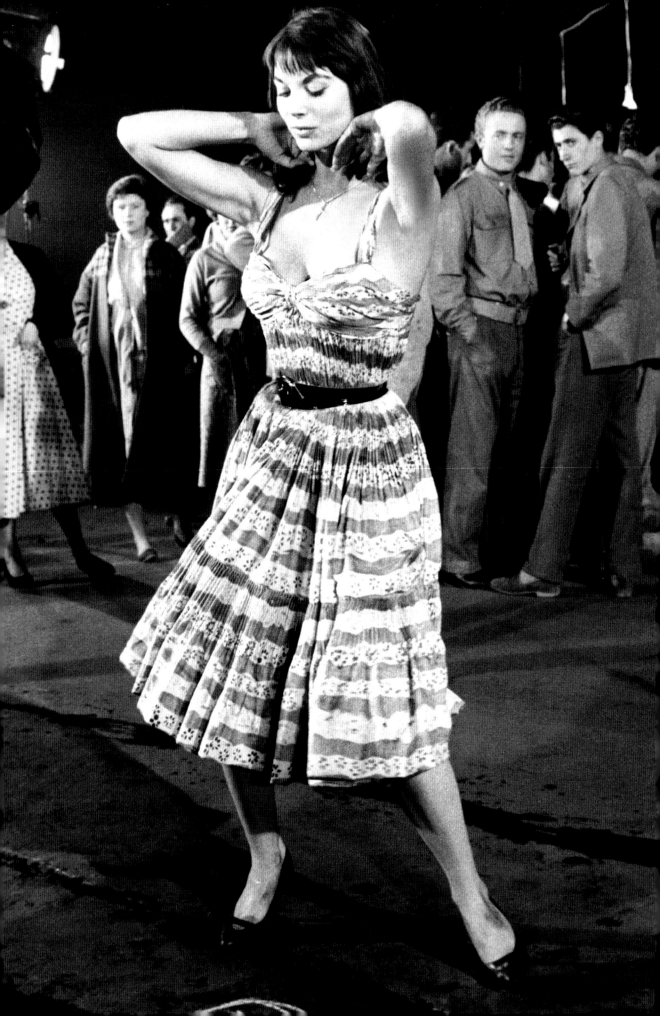

Fellini had a lot of fun with women, but it was never anything very serious. He really did have only one woman in his life, and her name was Giulietta Masina. He lived with her for fifty years, and they made several masterpieces together: *La Strada, Nights of Cabiria, Ginger and Fred,* and *Juliet of the Spirits.*

California to Paris, Berlin, swinging London and the whole of Europe, including Prague and its "spring," when Soviet tanks crushed all revolt, were still a long way off.

In the merry-go-round of the damned that *La Dolce Vita* was, three portraits of women emerge, at times with great erotic power. None plays the leading role, because there is no leading role in that world. It is still so present, and raises questions about itself; it hesitates before dying, with the journalist Marcello Rubini being merely the witness of its end, the link between repeated nights and dawns, a statue of motionlessness in a world where nothing changes. And yet the three women remain in our memory, for very different reasons.

"People say that women are scary," said Fellini. "The word scary, or fear, is exaggerated. Curiosity, interest, a sense of expectation, yes. But fear is a feeling that needs cultivating for a creative person. I think that man can't do without being afraid, because this attitude of anxiety and expectation with regard to what we don't know gives us a more profound sense of life. A man who is fearless would be an idiot or a robot. When we regard this feeling in relation to women, I think that, more than fear, the attitude that women suggest to men in general is very complex. It's a feeling made up of several strings. We project onto women a sense of expectation. A sense of the revelation of something, of the arrival of a message, like that Kafka character waiting for a message from the Emperor. Woman is perhaps the empress who, millions of years ago, sent off a message which did not get there."

Sylvia: Anita Ekberg, aglow

Federico Fellini traveled to London to meet Anita Ekberg, former Miss Malmö, former Miss Sweden, brought to Hollywood by Howard Hughes, and catapulted to international stardom at Warner Bros. with William Wellman's *Blood Alley* (1955) alongside John Wayne, and then, in

Previous pages: The eternal wife is sacrificed: Giulietta Masina in *Nights of Cabiria.*
Opposite page: Marcello's too-loyal companion: Yvonne Furneaux.

Frank Tashlin's *Artists and Models* (also 1955). The following year she starred in *Hollywood or Bust* by the same director, with Dean Martin and Jerry Lewis. Tashlin also directed *The Girl Can't Help It* in 1956, starring Ekberg's rival, Jayne Mansfield. In it, Mansfield played a star with a Mafioso boyfriend who tries to launch her as a singer. In a rock 'n roll ambience, Jayne strolled down the street and milk bottles spilled over (oh, what a metaphor!), blocks of ice melted, boys wolf-whistled, and glasses shattered. Fellini would bear in mind these metaphors for his portrait of a star in *La Dolce Vita* (Ekberg was actually meant to keep her own first name, but asked that it be changed to Sylvia, because the part reminded her too much of her marriage with Anthony Steele). She then played a supporting role in King Vidor's *War and Peace*, and made two forgettable films in Italy before *La Dolce Vita*.

Fellini melted at the mere sight of her: "Her little girl goddess beauty was dazzling. The lunar hue of her skin, the icy blue of her eyes, the golden sparkle of her hair, her exuberance, her joie de vivre, all made her a grandiose, otherworldly figure. I felt she was all aglow."

This was not everyone's opinion. On her arrival at Rome airport, Fellini and Mastroianni were there to meet her. She was all smiles for Fellini, but merely extended an inattentive hand toward Marcello, her future partner, her eyes elsewhere. Mastroianni would say:

"She's not that extraordinary. She reminds me of a German soldier in the Wehrmacht who, one day, in a raid, tried to make me get into a truck."

Marcello, the son of country folk, was sent to a work camp by the Germans, and managed to escape. Was it, however, because of this initial indifference that their sequence together worked so well? And because of it, too, that, more than twenty-five years later, in *Intervista* (1987), their meeting in front of the Trevi Fountain would be so moving? Projected onto a length of cloth, he would appear as a phoney

Opposite page: Super Star: Anita Ekberg-Sylvia.

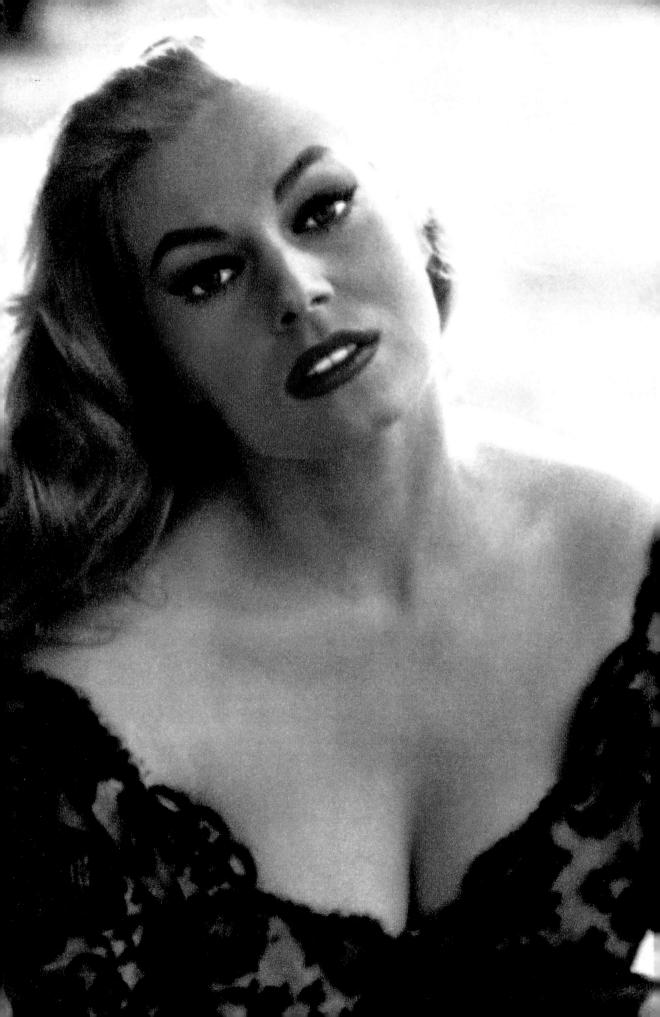

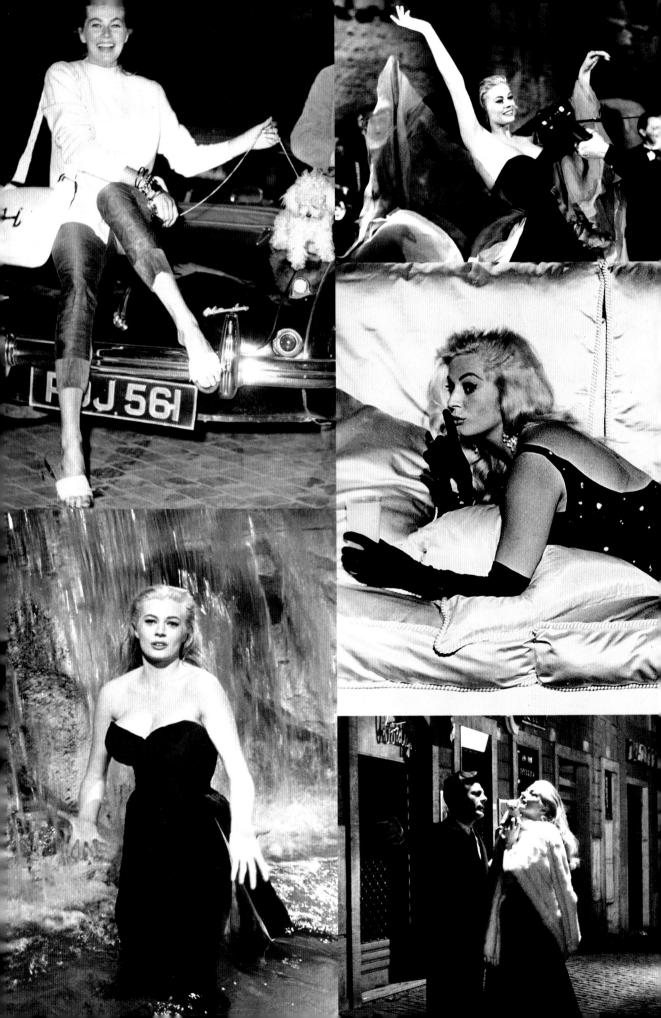

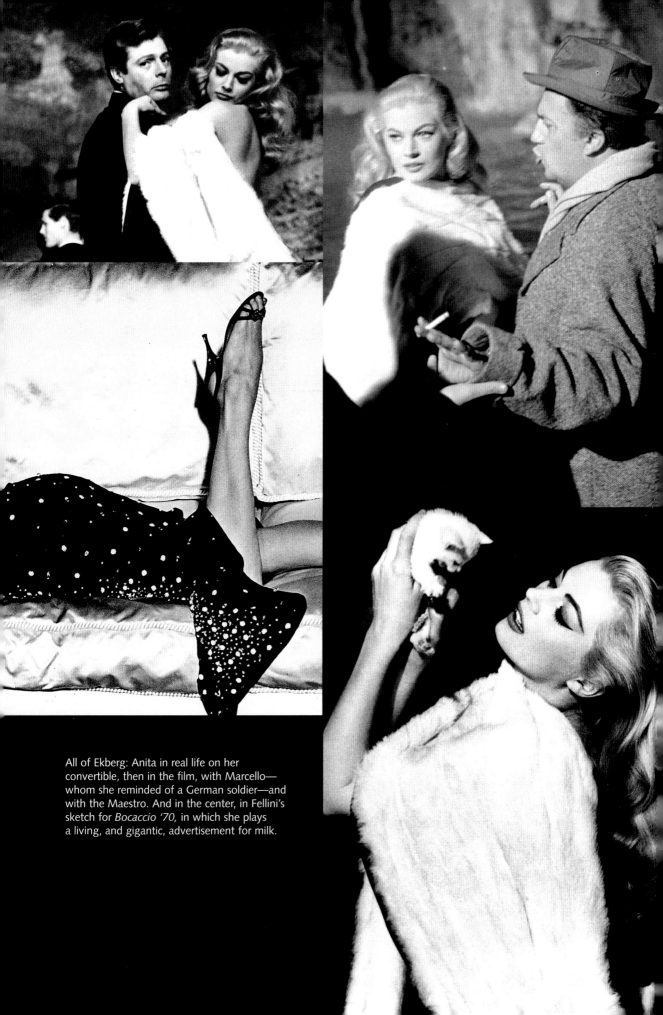

All of Ekberg: Anita in real life on her convertible, then in the film, with Marcello—whom she reminded of a German soldier—and with the Maestro. And in the center, in Fellini's sketch for *Bocaccio '70*, in which she plays a living, and gigantic, advertisement for milk.

Mandrake the magician for a TV commercial, she would have aged, and become fatter, and forgotten. Magic is the word…

"In *Intervista* I described the visit Mastroianni and I made to the house she lived in the country. She was a woman of a certain age who had grown fat, who lived with dogs and geese like a peasant woman. I saw that she was ageing well, a serene, wise old age. It was no longer the glorious image of the star she had once been. She seemed to me to be a fine example of serenity."

Fellini would refer to her in his *Boccacio 70*, a year after *La Dolce Vita*. She is a gigantic beauty on an immense poster in front of the windows of Dr. Antonio who, at the end of his tether, complains to both the town hall and the bishop (both powers that condemned *La Dolce Vita*). A revenge for both star and director. A vengeance in the form of a mocking smile, as well as a great display of tenderness for the artist and his model. After the milk bottles spilling over in Tashlin's film, here was a *Bibite latte* (drink milk) commercial in Fellini's work.

Woman is a "higher vital form" for Fellini, and Anita was the sumptuous incarnation thereof. "Woman," he told Damien Pettigrew, "for man in general and creative people in particular, is linked with a source of inspiration, something extremely nourishing." "Nourishing like mother's milk?" Pettigrew asked. "That's a very Italian image which I've used once or twice in my films. Let me repeat: woman is an ambassadress, and thus a powerful stimulus."

Anouk Aimée, to die for

Stars, along with their statue and status, have changed quite a bit since 1960 and *La Dolce Vita*. Apart from one. Apart from a character who retains an overall modernity: Maddalena. She is slim, which was no asset but has since become a reference; she is elegant in her supple, body-hugging, terribly chic yet simple dresses designed for her by Piero

Opposite page: The other rivalry: Anouk Aimée and Anita Ekberg.

[132]

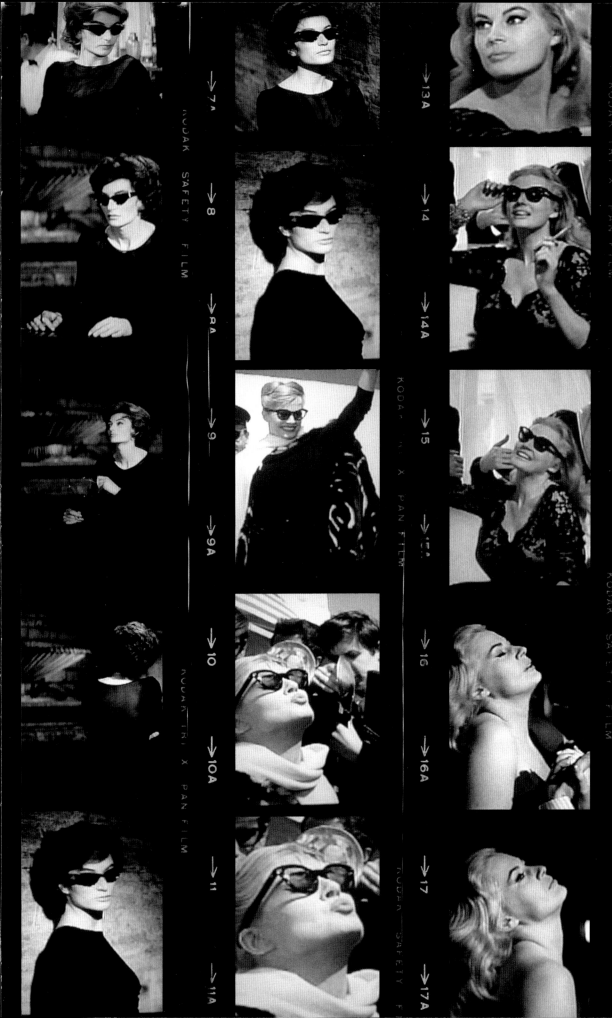

Gherardi. The latter seemed more lived-in by her than actually cladding her physique, which would travel through many a decade. The character is neurotic, rich, sophisticated, and seeking a happiness that she tries not to massacre, but ends up dissolving in the boredom of having nothing to live for.

Anouk Aimée slipped wonderfully into those clothes and that role. And it is from her, rather than from the sumptuous Anita, that the most permanent eroticism of *La Dolce Vita* emanates. Whenever Aimée is on the screen—at the prostitute's place, in the streets of Rome, or at the aristocratic party—she gives off this indelible eroticism. It is indelible because it is not flaunted. Trouble wells from her like a hidden light, and does not explode when spotted.

Anouk Aimée is the daughter of actress Geneviève Sorya. At a very young age she already had that secret, disconcerting beauty, which earned her the role of Juliet in *The Lovers of Verona* (André Cayatte, 1948). She then played in *The Crimson Curtain* (1952), a sketch by Alexandre Astruc for the film *Love Crimes*—which became a fetish film of the New Wave, still to make its appearance. In it Aimée is a girl who is ice-cold by day, and filled with sensuality by night. To die for… She then played under the direction of Anatole Litvak, Jacques Becker, and with younger directors like Georges Franju and jean-Pierre Mocky. And this is where she met Fellini.

The approach was awkward. Anouk Aimée was shy, and Fellini did not speak good French, but faced with the ultra-French charm of the actress, he felt the disturbing quality he wanted her to display as Maddalena. In the end, she became Anouchina, and was incorporated into his film "family." More than thirty years later, the Maestro felt just the same way: "She can be terribly shy one moment and, in a split second, she's a shark at the bottom of the sea. Under her girlish mask there's an almost metaphysical sensuality. This is why she was ideal to play the part of Maddalena in *La Dolce Vita*. Anouchina represents that type of woman who disconcert us to death."

To keep that disturbing gift, Fellini gave orders to Piero Gherardi: "*La Dolce Vita* was inspired by a very fashionable style of dress. It was a kind of very chic and elegant dress, but cut a little bit like a bag with three holes for the head and arms, swathing, and thus completely covering up the woman's body. A women who wore such a dress seemed to me like some ravishing pure creature, full of life, but, in reality, she could be just a skeleton of vice and loneliness within."

These simple but stunningly chic dresses, which would negotiate the years, and whose range of models would appear in a cyclical way at fashion shows, wonderfully enhanced Anouchina's slim body. From Marcello Mastroianni's fleeting mistress in *La Dolce Vita*, she became his wife in *Fellini's 8 1/2*—after exploding in Jacques Demy's *Lola*.

Fellini, who had become a fan of psychoanalysis for reasons best known to himself, changed her from a neurotic and sexually very liberated woman of the world into a wife being cheated on. She stays beside her filmmaker husband who tends to dream more than live or create, and for whom she is one of the fantasies in his dreamed-of harem. The hero's inspirational breakdown (which matched Fellini's) combines with a conjugal breakdown. Here again, Fellini and the great costume designer Gherardi dress Luisa/Anouchina differently from other female characters. White shirts and almost ubiquitous dark glasses (discretion with regard to Guido/Marcello's infidelity)…but all the while, desire and love. For both dream about things other than their sorry present. They summon up their past and their imagination, and let themselves be taken over by a mess of mental images that represent their relationship. At the end of the road? In the final round, Luisa's hand slips into Marcello's. He rediscovers his creative talent, and her. A new dawn, or the simple convalescence of a wounded love. Anouk/Luisa, it must be said, eclipses Claudia (Cardinale), the dream girl, and Carla (Sandra Milo), Guido's vulgar mistress. And the image of her, wearing black

Following pages: Anouk Aimée in *La Dolce Vita* with Mastroianni, whose wife she will play in *Fellini's 8 1/2*.

She is slim, which was
no asset but has since
become a reference;
she is elegant in her supple,
body-hugging, terribly chic
yet simple dresses designed
for her by Piero Gherardi.
The latter seemed more
lived-in by her than actually
cladding her physique,
which would travel
through many a decade.

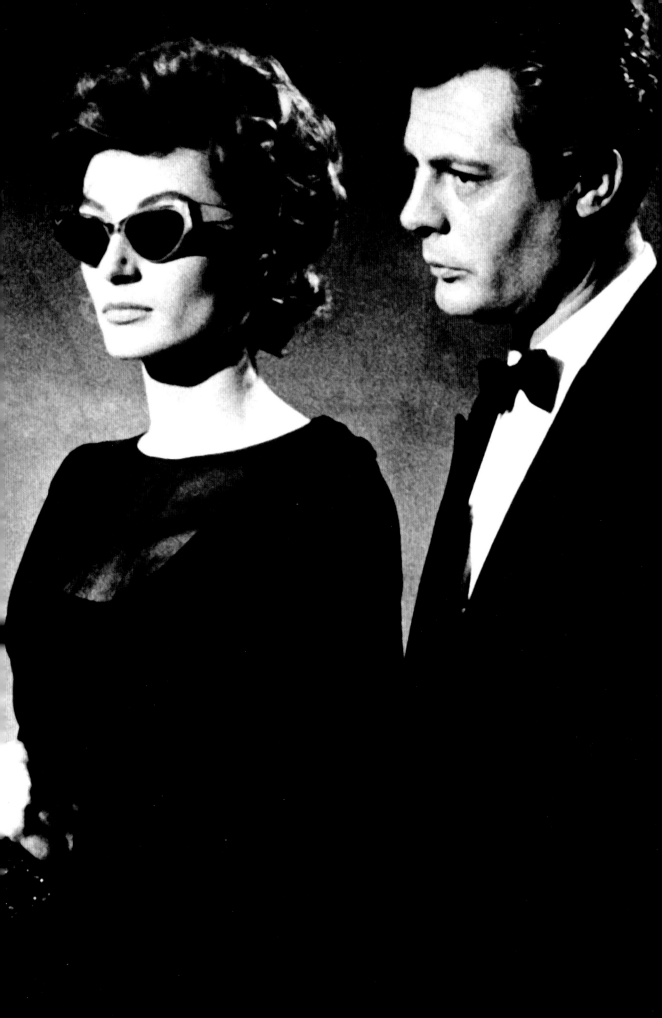

pedal pushers and a white blouse, eyes hidden behind very elongated dark glasses, walking along a railway platform where she will be joined by her husband, remains the ultimate feminine one.

She will reappear in a similar Fellinian image in Altman's *Ready to Wear* (1995), a zany symphony about the futility and emptiness of things. A rich gallery of characters wrenching the actors from their routine, a eulogy to fickleness and versatility. Produced thirty-five years later, this film could have been a funny *La Dolce Vita*: its adaptation to the new world of the 1990s, a fin de siècle drawn out the way *La Dolce Vita* had been a week's worth of the world's end. In that surprising and funny *Ready to Wear* (which also starred Mastroianni), Anouk Aimée plays a great fashion designer who is out of inspiration (the female counterpart of Guido and Federico). Having no collection to show, she gets her models to walk naked down the runway. It is a scene worthy of *La Dolce Vita*, and akin to the ecclesiastical fashion show of *Fellini's Roma*. But it is solely because of the invariably insolent beauty of Anouchina that an unwitting rapprochement occurs in the viewer's mind. And probably the director's too. Let us note that the *Ready to Wear* poster showed the nakedness of those superb women at the show, and caused something of a scandal.

"Anouchina troubles us to death," said Fellini. Isn't that so?

Valeria Ciangottini, the angel with her feet on the ground
She will remain Paola, that's all. But Paola in *La Dolce Vita* means a whole lot.

The very young, very blonde Valeria Ciangottini only makes two fleeting appearances in *La Dolce Vita*, but she remains a subject of amazement and wonder.

She has the uncertain gracefulness and natural smile of childhood without giving into the conventions of angelic mythology—even

Previous pages: And in Jacques Demy's *Model Shop*.

though in the sole scene when Marcello is relaxed and serene, he tells her that she looks like an angel.

The blonde child's pretty feet rest on the terra firma of the century: she is a waitress in a restaurant, but would like to be a typist. She likes listening to the rowdy and seductive music of her day and age.

She is neither a pure spirit nor an apparition, but a real girl who has not yet been contaminated by the unwholesome ambiences of the film, and thus of the world; she consequently retains a certain ingenuous rigor capable of arousing Marcello's attention and his vaguely admiring curiosity. Paola is less a symbol than a point of reference.

At the center of the disenchanted and futile human swarm there is someone like Paola, calm, simple and smiling; a girl who has no message to get across, but who is at ease in her skin.

In the motionless world we have described, only Steiner and Paola evolve. He towards death, she towards the future. She prepares for it by doing a job that she knows she will quit.

Marcello meets this girl again at the end of the film. He does not recognize her right away, and does not understand what she shouts to him. She, on the other hand, gesticulates and smiles as if to remind the journalist of that famous and ordinary afternoon when, in a seaside inn, the sun created a tranquil peacefulness and spread a kind of grace unknown on Via Veneto.

"Woman is the empress who sent off a message that didn't arrive," said Fellini. "The taste for life is in the waiting for this message and not in the message itself…" An empress, Paola? No, more like a little princess of the people disguised as a waitress, like in fairy tales. Her blondeness, her fresh and simple dress, and her innocent but serious gaze all actually send a message to Marcello. Does he still feel like waiting for her? Even though he turns his back on her at the end, we can hope he does.

For Valeria Ciangottini, Paola is the most delicate flower, the merest blade of grass, growing in the sand of this devastated landscape. And there is nothing more patient than a blade of grass.

Paola is the only "sweetness of life" in *La Dolce Vita*; and the fact that Valeria Ciangottini is already a woman, yet remains a child removes any mis-interpretation and any irony from the immediate translation of the title.

Opposite page: The "angel" with her feet on the ground: Valeria Ciangottini. She later became a choreographer. Following pages: The finale: a feeling as incommunicable as that of Michelangelo Antonioni's *L'Avventura*. Marcello Mastroianni and Valeria Ciangottini in *La Dolce Vita*'s final scene.

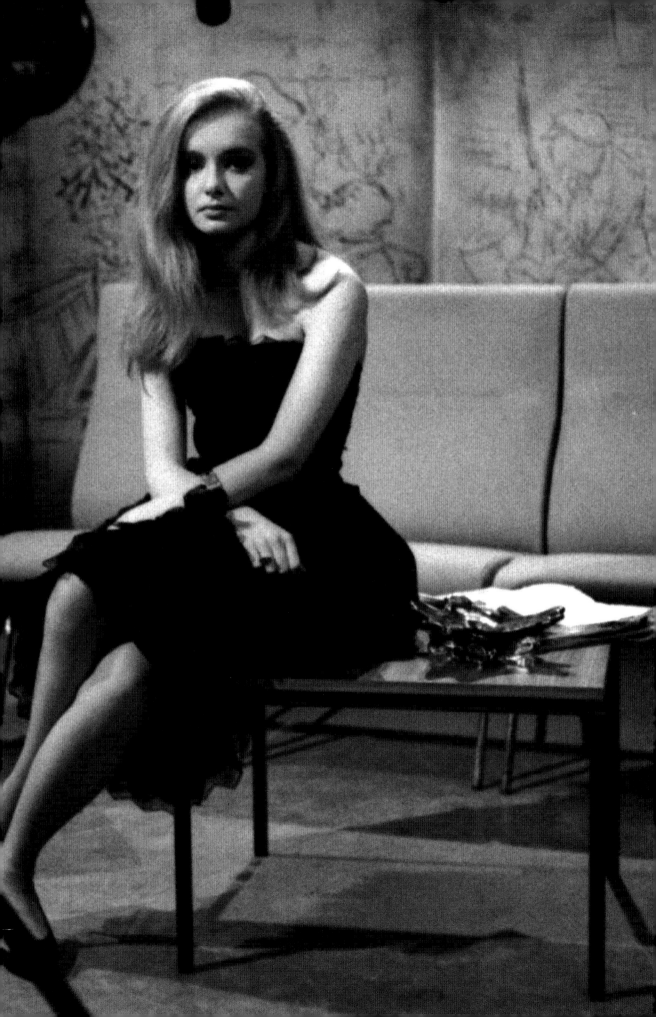

→19A →20 →20A →21 →

KODAK TRI X PAN FILM

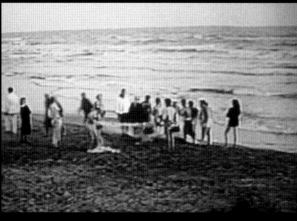

→13A →14 →14A →15

KODA X PAN

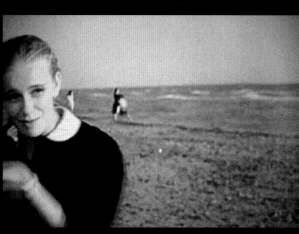
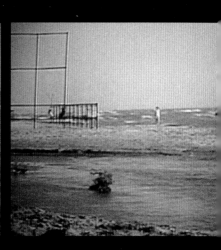

→7A →8 →8A →9

KODAK SAFETY FILM

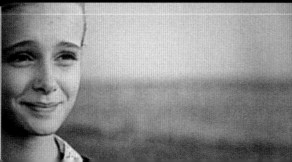
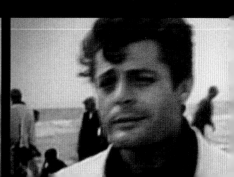

→ 22 → 22A → 23 → 23A

KODAK SAFETY FILM

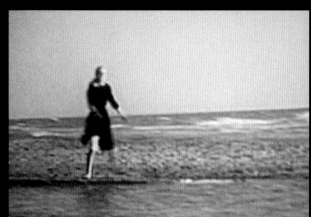
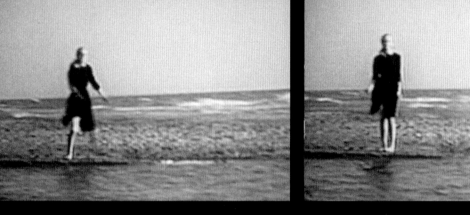

→ 16 → 16A → 17 → 17A

KODAK SAFETY F

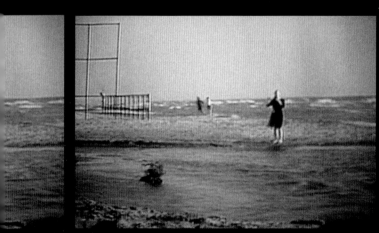
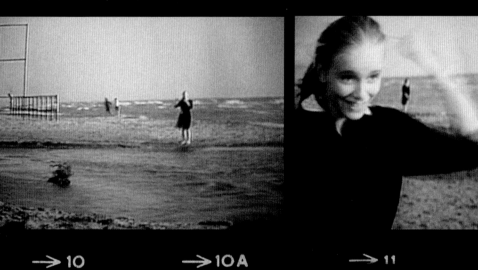

9A → 10 → 10A → 11 → 11A

KODAK TRI X PAN FILM

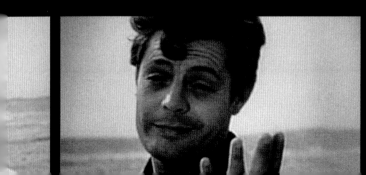
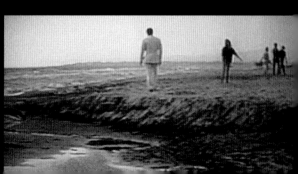

[CLOSING CREDITS]

Closing credits

To start with, *La Dolce Vita* was released in France under the French title *La Douceur de vivre* (The Sweetness of Life). It never worked. All over the world *La Dolce Vita* remained *La Dolce Vita*, and still does.

The film runs for 178 minutes. It has seven sequences, which are in no way separated by insert titles; rather, they slide into one another. Each sequence stages the appearance of new actors and actresses. The credits are thus quite long. We have decided to include them in full, including the parts played by the actors and actresses, so that film buffs will feel at home when they see the film again.

So here are all the people involved (apart from the real aristocrats, who did not want their names to appear) who gave us "the sweetness of life" (sic).

LA DOLCE VITA
Directed by: Federico Fellini.
Screenplay: Federico Fellini, Ennio Flaiano, Tullio Pinelli, Brunello Rondi.
Artistic collaboration: Brunello Rondi.
Assistant directors: Paolo Nuzzi, Guidarino Guidi, Dominique Delouche, Giancarlo Romani, Gianfranco Mingozzi, Lilli Veenman.
Photography: Otello Martelli.
Cameraman: Arturo Zavattini.
Assistant cameraman: Ennio Guranieri.
Sets and costumes: Piero Gherardi.

Opposite page: Fellini and Mastroianni in the 1960s.
A seamless complicity. Or the artist and his model (and viceversa)…

Assistant decorators: Giorgio Giovannini, Lucia Mirisola, Vito Anzalone.
Sound: Agostino Moretti, Oscar di Santo.
Edited by: Leo Catozzo.
Assistant editors: Adriana Olasio, Vanda Olasio.
Music: Nino Rota.
Conducted by: Franco Ferrara.
Rock Music: Adriano Celentano and the Campanino.
Production: Giuseppe Amato, Angelo Rizzoli pour Riama Film (Rome),
Gray Film, Pathé Cinéma (Paris).
Executive producer: Franco Magli.
Production managers: Manlio M. Morelli, Nello Meniconi.
General organizer: Clemente Fracassi.

CAST
Marcello Mastroianni (Marcello Rubini);
Anita Ekberg (Sylvia Rank);
Anouk Aimée (Maddalena);
Yvonne Furneaux (Emma);
Alain Cuny (Steiner);
Renée Longarini (Mrs. Steiner);
Nadia Gray (Nadia);
Magali Noël (Fanny);
Valeria Ciangottini (Paola);
Annibale Ninchi (Marcello's father);
Walter Santesso (Paparazzo);
Jacques Sernas (Matinee idol);
Riccardo Garrone (the Villa owner);
Mino Doro (Nadia's lover);
Lex Baker (Robert, Sylvia's husband);
Polidor (the clown);
Harriete White (Edna, Sylvia's secretary);
Alain Dijon (Frankie Stout);
Giulio Girola (Dr. Lucenti);
Nico Otzak (sophisticated women on the Via Veneto);
Audrey McDonald (Jane) ;
Giulio Paradisi (Tiziano, the second photographer);
Enzo Cerusico (the third photographer);
Enzo Doria (the fourth photographer);

Carlo Di Maggio (Toto Scalise, the producer);

Adriana Moneta (the prostitute);

Enrico Glori (Nadia's admirer);

Gloria Jones (Gloria);

Lilly Granado (Lucy);

Massimo Busetti (the chatterbox on the Via Veneto);

Carlo Musto (a transvestite);

Laura Betti (Laura, the singer);

Ida Galli ("debutante of the year");

Cesare Micheli (the angry man dancing);

Donatella Esparmer, Maria Pia Serafini (the women with the angry man);

Oscar Ghiglia, Gino Marturano (the pimps);

Thomas Torres (the journalist at the hospital);

Carlo Mariotti (the nurse);

Leonardo Botta (the doctor);

Francesco Luzzi (the radio journalist);

Adriano Celentano (the rock singer, in fact himself);

Gianfranco Mingozzi (the priest in the Steiner home);

Rina Franchetti (mother of the children who saw the Madonna);

Aurelio Nardi (their uncle);

Giulio Questi (don Giulio Mascalchi);

Franco Rosselini (the handsome rider);

John Francis Lane (a journalist);

Alessandro von Norman (interpreter at the press conference);

Fabrizio Capucci (the photographer at the press conference);

Franca Pasut (the woman covered with feathers);

Archie Savage (the black dancer);

Leonida Repaci (a guest of the Steiners).

(From: Gili, Jean A.. *Le Cinéma italien*. Paris: La Martinière, 1996.)

[PHOTO CREDITS]

This book is also dedicated to Michel Grisolia, a writer, scriptwriter, and critic. He wrote the *Movie Game Book, A Serious Pursuit of Film Trivia* with Pierre Murat (Assouline, 2004). He gave spirit to the "Viva Fellini" special issue of *L'Express*, written in May 2003 for the Cannes festival. Michel was an erudite with a lively and sharp style. He was a gentleman behind his great smile.

The author would like to thank the following: Damien Pettigrew (*Fellini : Je suis un grand menteur.* Paris: L'Arche, 1994), Gilbert Salachas (*Federico Fellini.* Paris: Seghers, 1963), Françoise Pieri (*Federico Fellini, conteur et humoriste.* Paris: Institut Jean Vigo, 2000), Tullio Kezich (*Federico Fellini, la vita e i filmi.* Milan: Feltrinelli, 2002), Jean A. Gili (*Le Cinéma italien.* Paris: La Martinière, 1996). Reading them while researching for this book was a pleasure.

The publisher would like to thank Susan Train for her amazing memory of the history of *Vogue*, as well as Francesca Alongi, Javier Arroyuelo, David Bailey, Gian Paolo Barbieri, Olivia Berghauer (Valentino), Caroline Berton, Iann Roland Bourgade, the Brioni archives, Elizabetta Catalano, Alberto Cavalli (Dolce & Gabbana), Alessandra Corti (Alinari), Serge Darmon (Christophe L.), Arthur Elgort, Getty, Fabienne Grévy (AKG Photo), Mats Gustafson, William Klein, The Kobal Collection, Haidee Finlay Levine, Magnum Photos, Steven Meisel, Daniela Merico (Olycom/Publifoto), New Roma Press Photo/Prestige, Roberto Palma, Paola Renna (Vogue Italie), Carlo Riccardi, David Secchiaroli, Stefano (Leemage), Denis Taranto (Jet Set), Catherine Terk (Rue des Archives), Vera Silvani (Scala), Michael Stier and Gretchen Fenston (Conde Nast), Wanda (Luigi Salvioli), and Michèle Zaquin.

[BY THE SAME AUTHOR]

With Assouline Publishing:
Hitchcock Style, 2003.

Also by Jean-Pierre Dufreigne:
*Louis XIV***, du temps où j'étais roi*. Paris: Plon, 2005.
*Louis XIV**, les passions et la gloire*. Paris: Plon, 2003.
Louis XIV, le lever du soleil*. Paris: Plon, 2002.
Le Procès perdu de Thomas D.. Paris: Ramsay, 2002.
Bref traité de la colère, une passion interdite. Paris: Plon, 2000.
Stephen King, le faiseur d'histoires. Paris: Mazarine, 1999.
Boire. Paris: Grasset, 1996.
Le Génie des orifices : esthétique des plaisirs de la table et du lit. Paris: Belfond, 1996.
*Le Dernier Amour d'Aramis.*Paris: Grasset, 1993.
Mémoires d'un homme amoureux. Paris: Grasset, 1990.
La vie est un jeu d'enfant. Paris: Grasset, 1984.
Supplique au roi de Norvège. Paris: Flammarion, 1983.
Je danse pour les cannibales. Paris: Flammarion, 1980.
La Prochaine Polaire. Paris: Flammarion, 1979.